TALES OF INNER TURMOIL I

Susan Widdicombe

Copyright © 2018 Susan Widdicombe.

All rights reserved. No part of this book may be reproduced, stored, or transmitted by any means—whether auditory, graphic, mechanical, or electronic—without written permission of the author, except in the case of brief excerpts used in critical articles and reviews. Unauthorized reproduction of any part of this work is illegal and is punishable by law.

This is a work of fiction. All of the characters, names, incidents, organizations, and dialogue in this novel are either the products of the author's imagination or are used fictitiously.

ISBN: 978-1-4834-8761-8 (sc)
ISBN: 978-1-4834-8763-2 (hc)
ISBN: 978-1-4834-8762-5 (e)

Library of Congress Control Number: 2018907596

Because of the dynamic nature of the Internet, any web addresses or links contained in this book may have changed since publication and may no longer be valid. The views expressed in this work are solely those of the author and do not necessarily reflect the views of the publisher, and the publisher hereby disclaims any responsibility for them.

Any people depicted in stock imagery provided by Getty Images are models, and such images are being used for illustrative purposes only.
Certain stock imagery © Getty Images.

Lulu Publishing Services rev. date: 07/17/2018

For Robbie

Contents

Acknowledgements..ix
Introduction...xi
1 Train..1
2 A Suitable Girl...5
3 A Change in Lifestyle..9
4 The Heir...13
5 Ransom..19
6 Sex and Love...23
7 The Christmas Party..27
8 Day of the Dead...31
9 Trial and Sentence...35
10 A Fresh Start..39
11 The Second Marriage..43
12 Mid-Life Crisis..47
13 Sensory Perception..51
14 Something Stupid..57
15 A Warm Spring Morning..63
16 Taking Sides...67
17 Lobola...71
18 Rosa..75
19 Piña Colada..79
20 Blind Faith...83
21 Holiday...87
22 Fear...93
23 A Walk in the Park..97

24	A Gathering	101
25	Revenge	105
26	Liberation	109
27	Fire	113
28	Control	117
29	Observation	121
30	It's Midnight Now	125
31	The King and the Cow	129
32	A Great New Year	133
33	After the Party	139
34	Swan Song	147

Acknowledgements

With special thanks to Tony and my friends and fellow writers at the U3A Creative Writing Group of Marbella and, of course, to Lulu Publishing.

Introduction

You may find some of my story titles or subjects somewhat strange. This is because our Creative Writing Group is given a particular word, phrase or subject to write about each week. Our task is to produce a short piece of fiction of between 700 and 1200 words. We then read our stories out loud and the others provide constructive criticism. And this is how these stories were born. I hope you enjoy them as you sit waiting in an airport, train station, bus stop or at the dentist's, outside the fitting room where your wife is trying on clothes, at the kitchen table with a glass of wine at midnight waiting for your husband to return from buying that packet of cigarettes, as you lie in bed with insomnia...

Go, little book, and wish to all
Flowers in the garden, meat in the hall,
A bin of wine, a spice of wit,
A house with lawns enclosing it,
A living river by the door,
A nightingale in the sycamore!
 - *'Envoy' by Robert Louis Stevenson (1850-1894)*

⌘ 1 ⌘

*T*rain

"This is the right train," the old man said to me as we scrambled aboard. "The others are doomed." There were too many of us for the space and we had to take turns sitting down. I managed to push up against the wooden slats on the side so that I could turn my back on the others and look out.

We trundled past green fields with black-and-white cows that stared as we passed. There were lines of trees and sometimes the peaked roofs of wooden farmhouses and barns, the sun glinting off windows. Dogs barked and the smell of spring was in the air.

We shared the little food we had and passed round water bottles but by the second day the water was all but finished. "It won't be long now," people reassured each other. They started singing old traditional songs to keep their spirits up. A gaunt man with a little boy on his shoulders sobbed while the boy in a blue-and-white striped T-shirt laughed and clapped his hands.

It grew hotter and hotter. Soon, the singing petered out and the stench of sweat and human detritus was difficult to bear. People clawed at my back, trying to reach the apertures and I made room for the man with the boy on his shoulders. I sniffed the fresh air and held my place.

The hunger was bad but the thirst was worse. On the third day, we passed through a station and stopped for a moment. Soldiers milled around the platform. Suddenly a guard came by with a hosepipe and sprayed water at us through the slats. I opened my mouth and a few icy

golden drops landed there. Then there was shouting and the guard was frog-marched off while his hosepipe just lay there, gushing water onto the ungrateful ground.

A solder in a tin helmet materialised, beating at the open slats and our clutching hands with the bolt of his rifle. People moaned but I held on, even though my hands were bleeding and one of my fingers might have been broken. The pain helped me focus and stopped me from falling.

The train shuddered and heaved into motion again and we were on our way, Poles and homosexuals, gypsies and Jews. No one spoke now. Mouths were too dry.

Then the haggard man passed the boy onto my shoulders, pleading with his eyes as he started sinking. As he vanished below my line of sight, another immediately took his place like water filling a vacuum.

"Look," I said to the boy. A horse pulled a plough in a distant field, a man trudging behind.

The boy clutched my hair and said nothing.

Another night and another day went by. We passed the odd village but the train didn't stop again and the few people on the platforms averted their gaze as we clattered inexorably onwards.

Finally, we seemed to be slowing down and there were soldiers standing around with their rifles over their shoulders, smoking and watching, their eyes unreadable. The moaning grew louder as we creaked to a halt alongside the station platform. I could see a great arched gateway stark against the bright blue sky. But there was a strange smell in the air, a smell that reminded me of a pile of old tyres that had caught fire in a vacant lot in the town where I was born.

We heard the clang of bolts being shot back one by one and people waited expectantly, then it was our turn. We stumbled to the ground, the boy as dry and light as a twig on my shoulders. And looking back, I saw the old man who had told me that this was the right train, lying inert, his body like a melted wax candle on the filthy seething floor.

We staggered in the direction of the giant gateway, herded by soldiers. Apart from the shuffling of our feet, the silence was eerie. Then I noticed a pale plume of smoke twisting up from a tall red brick chimney

and realised, with no feeling at all, that we had not been in the right train after all.

But I made it through and out the other side and, many decades later, I still see the little boy's laughing face and blue striped T-shirt in my dreams. He claps his hands and the noise gradually but inexorably mutates into the rhythm of that train: it's happening again, it's happening again, it's happening again... and I wake up in a sweat.

⌘ 2 ⌘

A Suitable Girl

She slid out of bed, gathered her clothes and dressed silently. She left the bedroom and didn't look back.

Felix watched her surreptitiously through his eyelashes until she slipped out of the door, pulling it to behind her. He heard the floorboard in the passage squeak, the bathroom door close and the water running in the basin as she brushed her teeth.

Yes, his mother would definitely have liked this one. She was different: clean, considerate. Perhaps this really was the one.

The lady psychiatrist had told him that what she called his 'murder fantasies' would gradually disappear as he learned to accept his mother's death. The psychiatrist didn't understand, even though he had tried to explain more than once, that he had failed his mother terribly. She had wanted him to marry a good girl, a suitable girl, who could cook, would keep the house clean and would look after him (and her) and - who knows? - perhaps even give her grandchildren. But Felix seemed to attract the wrong sort of girl, the sort who just wanted to have a good time, drink too much and fall into bed with him on the very first night. Of course, he obliged - it wouldn't have done to be rude - but he knew that this sort of girl wasn't the kind who would cook, clean or even consider marriage or children. At least not with him.

He hadn't really worried about it until his mother died. He had always assumed that things would turn out all right in the end. There was no hurry. He was only thirty-two.

But after the cremation, he wanted to make it up to his mother, to show her, even if rather late in the day, that he could do it, that he could make her (and incidentally himself) happy.

All it would take, surely, was a minimal effort. He knew that the bar on the corner wasn't the right place. Plenty of girls went there in the evenings after work but they were the wrong sort of girl, the one-night-stand sort. The last one, Frieda, had even told him that there was something unsettling about him.

The bathroom door opened and he could hear the girl tiptoeing down the stairs. He monitored her progress through the squeaky boards halfway down where the staircase changed direction. He held his breath and waited, betting that the next thing he heard would be the front door clicking softly closed behind her.

But instead, he heard the rattling of crockery, the click-click of the gas lighter and the metal-on-metal of the coffee machine being screwed together then placed on the gas ring. Cupboards opening and closing, the faint clink of cups and saucers, then the slow bubbling of the coffee as it rose and the heavenly aroma seeping upstairs to where he lay in bed.

But he wasn't in bed. He was leaning over the bannisters watching the open kitchen door and the sliver of floor with the table leg and, yes, her leg as she moved back and forth between the stove and the table.

She was quite nice looking too. No make-up, plain straight brown hair, flat shoes and a flowery dress that his mother might have worn before she had put on all that weight. He had found this girl (he experimented with the word 'fiancée' in passing) in the Chinese restaurant across the street where he was waiting for his takeaway. She had been waiting for hers too and they had shyly started up a conversation. She worked in a library in the next street and lived with her older sister and brother-in-law and regularly baby-sat for their two-year-old. He realised that she wasn't one of the one-night-stand girls and made a date to have dinner in the Italian restaurant nearby, the other place he usually went to for his takeaways.

The dinner went well and he was impressed with the girl's simplicity. She was just the sort that would have won his mother's reluctant seal of approval. Pity his mother wasn't around any longer to help him decide.

He'd have to make the decision himself and felt this as a daunting responsibility.

In the meantime, he and the girl continued to meet a couple of nights a week, when she wasn't baby-sitting and after he had finished his stint at the supermarket and his journey home in the tube.

During the six months they went out together, he had, of course, gone out with other girls, the ones from the bar that would agree to go to his flat on the first night. There were four of them and they all ended up the same way. He never saw them again and, of course, they were never seen again in the bar either.

Her name was Sharon, the one his mother would have approved of. Last night, he had decided to ask her to marry him. She flushed and said, "Yes," then shyly went home with him. They talked about the wedding and whom they would invite then ended up in bed. And she had been fine, gentle and considerate, as he would have wished his wife to be.

He had found out that she cooked well, had no objection to doing housework and was eager to start a family. Such a pity that his mother hadn't lived long enough to meet her. Ah, if she could only see him now!

He watched over the banisters, expecting Sharon to bring his coffee up to him but she suddenly appeared in the kitchen doorway and looked up. Her face broke into a smile when she saw him.

"Good morning. I've just made coffee. I hope you don't mind. Coming down?" Her voice was pleasantly musical, respectful and affectionate.

He smiled back and went down to the kitchen to join her. He would have whistled with satisfaction if he'd known how.

But as they were sipping their coffee, she said "I've decided to make lunch for us, as a treat." He nodded encouragingly. "I thought I'd make some fish."

She stood, put her cup in the sink then walked around him, stroking his shoulder as she passed and kissing the top of his head.

"Good idea," he said. "In fact, there's still some shrimp left from dinner on Wednesday. I put it in…" His voice faltered as he realised what he had said.

"Oh good!" she replied, making for the door. "The freezer's in the garage, isn't it? I'll just go and check." She was already walking down the passage before he could say, "No, don't!"

He knew it was too late and that everything was ruined, even before hearing her scream. He sighed as he reached for the bread knife he usually used, pushed back his chair and made his way, shoulders slumped in disappointment, towards the garage.

⌘ 3 ⌘

A Change in Lifestyle

An orange moon had risen against the indigo sky as the Hasletts and their two servants, Joseph the garden boy and Samuel the house boy, stowed the last bundles and boxes in the jeep and encouraged the two Rhodesian ridgebacks, one old and one young, to skitter over the front seats to the bed that had been made for them on top of the whole pile. John Haslett, powerful torch in hand, checked that he had left the box of toilet paper and dog food and the dogs' bowls easily accessible and that all the plastic jerrycans of drinking water and spare fuel were tightly screwed shut. Anne Haslett, thirty and pregnant with their first child, sat quietly, in shock, in the front seat.

The Hasletts were going to make for the closest border, in Mozambique, where John's brother would be waiting to accompany them back to South Africa and a new life. The border posts were dangerous places and a sack of dollars for bribes lay somewhere in the dark under Anne's feet. They were abandoning the farm and its fields of tobacco that John's grandfather had developed fifty years ago in the halcyon days. Now, with President Mugabe's new land reform programme and its expropriation without compensation, it just wasn't worth making the effort any longer. The killing of a white farmer just a few kilometres north of their farm was the last straw.

John shook hands wordlessly with Joseph and Samuel and Joseph could have sworn he saw the glint of tears under his boss's hat brim. Samuel was sobbing and wringing his hands. "You have safe journey,

baas, and good healthy baby, ma'am, you drive careful." Anne whispered, "Thank you, thank you," but couldn't say more in her distress at leaving the old farmhouse that she had so lovingly redecorated for her husband and future family. John pressed a wad of notes into each man's hand as he took his leave, clapping them on the back and wishing them well. The dogs were alert but well-trained and silent. At last, the jeep set off along the bumpy track in the direction of the Mozambique border, under cover of night.

Joseph had worked for the young Baas since John had taken over from his father, who had moved down to South Africa in the '80s, rightly fearing deterioration of the political situation. Although Joseph had known John since he was born, he wouldn't really miss his former employers. He knew about the land reform programme and knew that he had a right to this farm, with all the years of work he had put into it.

He walked slowly up the steps to the wide verandah then hesitated. Samuel was still sniffling and shuffling off towards the compound where they lived, in two grass-roofed huts with their concrete ablution block.

"Where you going?" Joseph demanded belligerently in their shared Shona language.

"Getting my bike. I'm going home", replied Samuel in a low but determined voice, his bottom lip still trembling. "They good people, the Baas and the Madam."

Joseph watched him until he disappeared into the black shadow of a flame tree. Stupid boy, he thought. Wants to go home on his bike. Joseph's lips twisted in disdain. Home for Samuel was Zambia, just a few thousand kilometres to the north. He'd be killed by any number of guerillas or Mugabe's supporters, both factions and more marauding through the country in army trucks, waving rifles and (luckily) singing at the tops of their voices, thus warning of their arrival long before they could actually be seen hurtling along the pot-holed untarred farm roads, giving the farm workers time to melt into the surrounding bush, where they were then eaten by leopard or bitten by mambas if they weren't overtaken by the soldiers. Oh well, no life was perfect and these days no death was perfect either, mused Joseph philosophically.

He slid open the wide glass doors leading into the vast living room

and ambled over to the drinks cabinet to pour himself a shot of Glenlivet from an almost-empty decanter into a heavy Stuart crystal glass. Then he settled himself comfortably in John's cane armchair on the verandah and lit up a joint. Joseph's marijuana crop was the only crop left now. The farm's irrigation machinery had broken down long ago and no spare parts could be found. The tobacco and maize crops had shrivelled and died in the drought. But Joseph secretly used the left-over dishwater and shower water for his few 'dagga' plants and they were doing fine.

Eyes yellow slits as he squinted through the blue smoke curling in front of that big orange moon, he reflected that he had never seen the farm from this position, sitting in the Master's chair. Stretching out his long legs in their old blue gardening overalls, he considered this new phase of his life with great satisfaction: himself as a legitimate (on a first come, first served basis, of course) settlor, nay, owner, of this beautiful farm. Who would have thought it?

Another sip of whisky made him cough - he preferred the rough beer he was used to. But now, as a farm owner, he should get used to the whisky. It was what all the owners drank, after all.

As the toke glowed red, closer to his fingers now, he thought about buying a wife. Nothing was impossible now. He had a future. That Samuel was mad to leave, but he had family whereas Joseph had no one. But not for long.

He sat until the moon moved to behind the high trees on the kopje and admired the hydrangeas he had so arduously planted. They, too, were completely desiccated but they looked attractive anyway, as dried flowers. Then, with the disappearance of the moon, there was nothing more to look at except the thick dark black of the night. The birds were silent, the air was hot and humid, the mosquitoes whined but Joseph was impervious. The only sound was the incessant scraping of the cicadas and the odd hoot of an owl.

Yes, a wife would do nicely. Or even two. He needed children to look after him in his old age and a wife or two to look after him now.

He was hungry. With difficulty, he heaved himself out of the comfortable cane armchair and wove into the living room. Oops - that tinkling crash must have been the whisky glass. He didn't look back - there

were plenty more in the sideboard. The fridge would surely be empty - but no! He discovered with surprise and delight that the Madam had left some bread and polony in there, obviously for himself and Samuel. He wolfed it down, crumbs raining onto the tiles.

Then into the Master and Madam's bedroom, the first time he had been into it although he had seen it through the window any number of times. The bed looked really comfortable, even without blankets. He sat on it and tested the mattress, then laid his black krizzy hair onto the pristine white pillows. What bliss! He closed his eyes and raised his gnarled rhinoscerosy feet to the mattress.

Oh yes, he was going to enjoy being a farmer. Or rather, owning a farm. He was a little hazy as to how the actual farming was done but he'd get people to do that for him. He was the Boss now.

And he drifted off to sleep, his hands folded across his chest, the hint of a smile curling his lips. He slept so deeply that he didn't even hear the raucous singing growing closer and closer as dawn broke, dying the land the colour of blood.

⌘ 4 ⌘

The Heir

Ling Chan sloped sulkily into the little breakfast room next to the kitchen. She would be sixteen in a week's time and had made up her mind. Taking her place at the table, she muttered a greeting to her parents and the two sets of grandparents already seated.

A flunky placed fresh bowls of sweet steamed buns, tofu pudding in ginger and brown sugar syrup and some dough sticks with a glass of soybean milk before her. She scowled. Silence reigned. She broke it with her announcement: "I've decided to go to university and become a marine biologist." There. It was said.

Everyone at the table froze, chopsticks half way to their lips. Grandmother Wong looked from one to the other, saying: "What? What? No one tells me anything!"

Ling's mother, elegant in her silks, perfectly coiffed and made up for breakfast as usual, slowly lowered her glass and said quite distinctly and bitingly: "I think not." She lowered her lashes and waited for her husband to repeat her opinion, thus making it binding on their daughter.

But he rattled his newspaper and leapt to his feet. "We'll discuss it this evening," he said to Ling with a smile, met with a pebbly stare. He said his goodbyes to everyone in turn, kissed his wife on the cheek and rushed off to the waiting car and the relative peace of his corner office in the Sang Ho building from whence he directed the affairs of his many casinos in Hong Kong and Macao.

That evening, Ling arrived at the dinner table to find only her

grandparents already there. She greeted them pleasantly but turned belligerent as her parents entered the room together. "You can't make me change my mind," she warned them. A flunky pulled out a chair for her mother who sat. Her father greeted everyone in turn and sat too.

"I have an announcement to make," he said, flapping out his damask napkin and placing in on his knees. All eyes swivelled towards him while his bored into his recalcitrant daughter. "You are not going to university. You are going to marry."

Ling hissed, "I'll do what I like. Han Wu's going to university in Beijing and I'm her best friend so I'm going too. I have rights, you know. I've decided..." Her voice trailed off as a photograph was presented to her on a silver salver. Ling's eyes fell on a veritable Adonis, a superbly handsome young man, even without the airbrushing.

Her mother told the grandparents smugly, "It's Gao Shi, the son of my dear husband's partner in Macao. He's from a VERY good family."

Thus it was that Ling, the spoilt only child of one of the richest men in China, was betrothed to the spoilt only child of another of the richest men in China: a match made in heaven. The matchmaker charged with negotiations had indicated that the *suan ming* of this marriage was definitely auspicious although she was hazy about offspring.

The wedding banquet was fabulous and Ling, herself quite radiant in her rich red silk dress ordered from Paris, found her new husband even more handsome in the flesh than in the photograph.

After the wedding and impatient goodbyes to her parents and grandparents, Ling went, of course, to live with her new husband's family in their vast mansion overlooking Zhuxian Park. And Ling's adult life began.

She was shrewd enough to control her adolescent outbursts in the presence of her mother-in-law although not shrewd enough to lower her eyes to hide her true rebellious feelings. But the mother-in-law was kind and offered discreet support and advice to the young girl. Not having been permitted more than one child, and that one child being her beloved son, she was delighted to have gained a daughter, and one from a VERY good family to boot. Lucky, really: due to the unmentionable killing or aborting of girl children in favour of sons who could

promulgate the patriarch's name, there weren't enough girls to go round these days.

In the privacy of the marital chamber, Gao Shi proved himself a nervous and eager-to-please husband and a sincere affection grew up between the couple as time went by.

But what didn't happen as time went by was the announcement of a much-awaited happy event. The mother-in-law's remarks gradually shifted from a cheerful "Don't worry, these things take time," (uttered during the second month of their marriage), to "Are things - you know, er, alright between the two of you?", to "Perhaps you should see someone...". Five years went by, in otherwise perfect accord, the marriage attaining, then maintaining, a peaceful, cruising speed.

Of course, it was assumed that Ling was "to blame" and she did go to visit the fertility clinic in Hong Kong, under a false name, since her husband was a nationally known figure, but was told that she was fertile. The doctor concluded that her husband must be sterile, adding that the condition was becoming increasingly widespread due to increased pollution. To Ling's enquiry as to a possible solution, the fertility doctor said that there was a very long waiting list for donor sperm but he would add her name to it if she liked. However, this couldn't be done without her husband's permission and Ling knew that what Gao Shi really wanted was his own child to perpetuate the family bloodline. It was a matter of honour.

Then one day, at the hairdresser's, after reading an article in a foreign magazine about people finding their soul mates on the Internet, a brilliant idea came to Ling and she lost no time in hatching her plan with the help of her old school friend, Han Wu.

"Darling," she told her husband that evening, "would you mind very much if I went to stay a couple of weeks with Han Wu in Shenzhen? I could visit my parents too." Gao Shi had no objections and her mother-in-law gave her permission for the visit, hugging Ling and disconcertingly wishing her luck.

Once in Shenzhen, and with only Han Wu aware of her plan, Ling booked into a luxury hotel in the upmarket Shekou district under her friend's name and using her friend's credit card. That evening, lying on

the king-size bed, she signed up with Jiayuan, China's largest on-line dating site. Her photo was heavily photo-shopped, not to improve her looks (in fact, quite the opposite) but to hide her identity. She, too, was well known to the Chinese press, attending charity balls and functions on the arm of her husband.

Then she waited for the contacts. And they flowed in. She examined all the photos carefully to weed out men who looked too different from her husband, and foreigners too, of course. But mainly she looked for men who lived in desirable locations in the city, or in Hong Kong just over the border, and who seemed likely, from their jobs and qualifications, to be blessed with a certain intellect. She also looked for signs that the men had children and that they were married, which would avoid complications further down the line.

She found three suitable candidates and made appointments to meet them on the following three evenings in three different restaurants close to the hotel. Two of the men were handsome and charming. And married. One said, "You remind me of someone, I can't think who," and she worried all night that he would remember. He had probably been at one of the balls she had attended. After a romantic dinner with each of them on different nights, she coyly agreed to visit their rooms and spent the night with each in their respective luxury hotels. The third one turned out to be some sort of scam artist who obviously had no class and was after her money so she left him sitting in the expensive restaurant with the bill while she visited the ladies' room and never came back.

Then, of course, she went to visit her parents before returning to her husband's house as arranged. As Han Wu had pointed out, she may have to repeat the exercise if it didn't work the first time around. But a month later, she knew that it had worked.

Her husband was beside himself with joy at the news and her mother-in-law declined to look a gift horse in the mouth. Instead, Ling was cossetted and prevented from lifting anything heavier than a toothbrush. She visited the city's leading Portuguese gynaecologist and a Chinese midwife too, for good measure. The soothsayer predicted an easy birth and a happy life - the stars were apparently cooperating.

Even better, the child was a boy! "It took long enough for you to

fall pregnant but it was worth the wait!" warbled Gao Shi in delight, bursting with pride in his son, his wife and above all in himself. What a relief. For a moment there, he thought something might even be wrong with *him*!

The boy, whom they called Michael, grew up healthy and happy under his parents' doting gaze. He was intelligent and ended up going to Columbia to study marine biology before returning to Macao and a lucrative government job. But in the meantime, China had changed its mind about the one-child-per-family system in the light of the resulting demographic crisis and young Michael was permitted, and able, to father no fewer than five children of his own with his beautiful quarter-Portuguese wife. Two of Gao Shi's grandchildren joined the family business and were groomed to take it over on Gao Shi's retirement.

Although she was sorely tempted, Ling never did tell Gao Shi of her shameful three nights in Shenzhen so he never knew. The telling would have been a huge weight off her shoulders but the burden would simply have been transferred to Gao Shi and this was not what she wanted. And she never knew that, until the arrival of his son and heir, Gao Shi had had a long-lasting affair with none other than Han Wu.

⌘ 5 ⌘

Ransom

We grabbed the brat from the car outside the general store in Calo Falo. It was all properly planned, of course, like the last time. The mother, Silvana Rossi, was married to some nonentity, a bank clerk in Milan, but her father was the richest landowner in Umbria and, according to Franco, the boss, would pay up without hesitation.

We were going to ask for at least 850 million lire (about half a million euros in today's money), which Franco said the landowner could easily afford.

I was the one who yanked open the car door and snatched the child before he could grasp what was happening while Umberto hovered, one eye on the store front opposite, where we could see the mother at the counter placing her order, and the other vetting the passers' by. It was all over in a jiffy. We had double-parked next to the mother's jeep and I'm pretty sure no one saw us transferring the boy to our unremarkable blue Fiat. Arturo hadn't even turned the engine off and pulled away before I had the door properly closed.

The child was whining now and blubbering. "Tape his mouth," snapped Arturo from the driver's seat, without turning round. "And blindfold him."

I had to do it, then I had to get the boy to blow his nose otherwise I couldn't see how he was going to breathe unless through his ears. The child went on sobbing in the back seat next to me and I was afraid he

would suffocate. I looked at him and went "Shhh," holding a finger up to my lips. He just held my gaze and gulped and made the effort but didn't manage really.

We drove and drove. At one point, we had to stop for petrol at the last station before the really impenetrable mountains started, I think it was in Orgosolo. I held the child against me, covered with a jacket. We took it in turns to grab a coffee in the bar then we were off again.

The road wound and wound and became narrower and bumpier as the forest encroached. We passed a tractor or two hauling trailers of logs, then nothing. The dark fell suddenly and the stars came out but the road was black. No municipal lighting up here. But Arturo knew the way well from the last time and we finally turned off onto the dirt track and bumped along for a couple of kilometres, the tree branches scraping the sides and roof of the car.

Finally, the old stone farmhouse that looked like a ruin from the outside sprung up suddenly as we went around a bend. I bundled the boy in the jacket so he couldn't see where we were. Not that he would have understood - he was only about six or seven. I took him around to the back yard, picking my way through piles of rubble and sheets of corrugated iron left over from some long-ago restoration attempt. Umberto came and pulled away the dirty blue tarpaulin that covered the entrance to the cave in the sort of cliff at the back of the house and I carried the boy in.

We had arranged a pile of dried ferns against the wall for him to lie on. There was a bucket and a tin cup with a 2-litre bottle of water in the dirt next to the makeshift bed. By the light of the stars and the full moon, I freed the boy of his blindfold and warned him that, if he shouted, firstly there was no one for miles around to hear him and secondly I would tape up his mouth again if he didn't behave. The child nodded, eyes wild. So I untaped his mouth and he whispered, "Where's Mummy?"

"You'll see her soon, don't worry," I said. Then I chained his left ankle to an iron ring in the rock wall like we always did. "I'll be back soon," I said. I pointed out the bucket for his slops and the water and told the child to lie on the bed of ferns until I got back.

I was tired and hungry so just grabbed some bread and cheese off the deal table in the farmhouse kitchen and took it back to the boy on a tin plate. "I'll see you in the morning," I said. He started screaming, "No, don't leave me in here!" as I lowered the heavy wooden door over the entrance to the cave and covered it with the tarpaulin and some broken bricks. The door cut off the child's screams effectively. The night was a totally silent witness.

The farmhouse was cold and damp and we couldn't light a fire or leave any traces of our passing. We wolfed down the bread and cheese and salami and gulped thick red wine from plastic cups before unrolling our sleeping bags and trying to catch some shut-eye before morning.

As the grey light of dawn showed through the slats in the old door, I was the first to awake. The air was cold and bracing outside and not as damp as it was in the farmhouse. I set the coffee going and the others woke with the aroma. They would be leaving today, going back to the city on the coast to negotiate the ransom. But first I had a job to do.

Taking some bread and a few slices of salami in a piece of newspaper, I tramped around to the back of the house and pulled away and tarpaulin then the wooden door. The cave stank of damp and excrement. The child put its arm up to shield its face from the morning light and whimpered. Then I squatted down next to the dank bed of mouldering ferns.

"Are you going to kill me?" the child whispered. "No, not if you're good," I replied. Then I gave him the salami and bread. There was still plenty of water in the bottle.

"Why did you steal me? Is Mummy coming? When can I go home?" the boy said in a low depressed voice. So I explained that we had stolen him so that his Mummy would pay us a lot of money to get him back. He thought a bit. "What do you need the money for?" he asked at last. "To buy more guns?"

So he had seen the gun that Umberto had been concealing under his jacket yesterday when we had snatched the child. "Without guns, we can't steal people. They wouldn't be frightened if we didn't have guns," I tried to explain. "And if they're naughty, you can shoot them dead," the child added, pleased that he had followed the logic.

I took out the knife with its horn handle, flicked it open and cut off a corner of bread, offering it to the boy. He didn't take it. "I'm not hungry. I want to go home."

I told him to face the wall because I had to do something. "It'll sting a bit but that's all so don't worry." I sprayed his right ear, the one that was showing, with the ice-cold anaesthetic then sliced off the tip, quickly and efficiently, and slipped it into the plastic bag and back into my pocket. Then I taped up the ear before the anaesthetic wore off.

"Is it done?" the child asked, his fingers hovering about his ear. "Don't touch," I said.

Then I left, pulling the door back over the entrance and covering it carefully with the negligent blue tarpaulin, held down with bricks.

What happened then was: Franco sent the ransom note, the mother gave a teary television appeal insisting that she didn't have the money, she offered a much lower sum which, she said, was all she had. So we sent her the ear. Then we found out that her father was Marcello Rossi, goatherd, and not Marcello Rossi, billionaire. So we took the money and killed the boy since he had seen us. I say "we" but I had to do it with the knife. For a split second, I thought of my own little boy and how I'd now be able to buy him a Christmas tree and more, thanks to the ransom money. Then I replaced the door and tarpaulin, covered my tracks and drove back down the mountain with the others.

⌘ 6 ⌘

Sex and Love

"Well," said Charles, "that was quite a bombshell!" His wife glanced at him driving seat-belted in the direction of home, his body bathed in the orange late afternoon sunlight, his handsome mouth smiling slightly, his eyes invisible in the shade from the sun flap.

"I think it's pathetic," she answered, looking out of the window at the trees on the boulevard, the cafés and green lights of pharmacies. "I mean, at their age. Couldn't they just have gone on living one upstairs and the other downstairs? What's the point?" Her mouth went sulky.

"I just wish he'd come and stay with us instead. If he's lonely, I mean," said Charles frowning. He saw Solange's lips tighten out of the corner of his eye. "After all, we've got the spare room in the basement with it's own bathroom and everything. Then we could take care of him without having to traipse into town all the time to make sure he's alright."

"You mean *I'd* have to take care of him. When are *you* ever there?" snapped Solange. They drove in silence for a while, the blocks of flats gradually thinning out into rows of little houses with neat front gardens.

"Well, you should be relieved he has someone to look after him. I must say, it's a load off my mind," said Charles. "But it had just never occurred to me that there might be something between them. I thought she was just a nice neighbour. I wonder what made them decide on marriage?" He sounded genuinely puzzled.

"Well, I think it's ... unseemly, unbecoming at their age," sniffed Solange. "In fact, it's disgusting!"

Charles raised an eyebrow, unsurprised.

Now, the small houses were giving way to larger houses with gardens you couldn't see from the road, security cameras winking from the tops of high bougainvillea-clad walls, until finally they turned into their own driveway.

That night as Charles touched her shoulder under the sheets, Solange turned to him with a sigh. They hadn't had sex in about ten days and she was careful not to leave Charles without for too long in case he looked elsewhere. But as tight muscles routinely met smooth soft contours, Solange shuddered at the thought of those two gnarled old bodies in the city sleeping in the same bed. Not that there would be anything else, of course. At least that was something to look forward to in old age. It was all she could do to stop from glancing at the bedside clock over Charles's shoulder.

⌘

In the city, Henri put his arms around his fiancée who was washing the dishes in rubber gloves. She smiled and leaned into him. "That didn't go too badly, now, did it?" she said.

Henri smiled too and kissed her neck. "Thanks to you. I would never have had the courage to tell them if it hadn't been for you."

Then he poured them each a tot of 20-year old Macallan and, the dishes done, they sat peaceably at the little round table on the narrow balcony off the sitting room, watching the traffic in the boulevard below, people queuing for the cinema, the bright lights of restaurants and cafés washing the pavements in orange, couples strolling along arm-in-arm in the balmy evening, the ubiquitous police car sirens somewhere near.

Emma took out one of her Californian cigarettes and Henri leant over to light it for her. "At least I won't have to hear any more about moving into that pokey room in their basement."

Emma laughed. "God, yes. Can you imagine being stuck out there in the suburbs with nowhere to go?"

"Talking of which, shall I go in tomorrow and book our cruise?"

"Don't forget to ask them for the discount for newly-weds." Emma caught Henri's eye and they gagged with laughter, choking on their scotch.

"It'll be so nice not to have to hide all my clothes and things when they come around. Pretending I'd just dropped in for a visit," she said.

Henri leaned over and stroked her cheek, leaving his hand on her shoulder. "Tomorrow we'll bring down the rest of your stuff."

Some time ago, when they had started sharing a bed, they had decided to convert Emma's flat upstairs into an art studio for her. She also kept her piano up there. Henri played duplicate bridge twice a week and sat on the Board of his old company, taking quite an interest in its affairs. Then there were the art exhibitions and concerts and, of course, their season ticket to the opera, so it had not been easy to find a suitable date for the wedding and honeymoon cruise. The wedding itself was taking place for strictly practical purposes concerning life insurance and spouse's pension rights, and of course to legitimise their relationship with Charles and Solange and the grandchildren.

Emma glanced at her watch and reached for her stick. "Time for bed," she said. Henri took the glasses back inside, locked up and turned off the lights while Emma took her turn in the bathroom. Once in bed, they turned into each other's arms as they always did. Henri whispered into her hair, "Did you see her expression when we told them we were getting married?" "Mmm," then she snorted with laughter. Gradually, their giggles abated and they kissed, gently then with growing urgency, and made love slowly and passionately until they lay back exhausted, smiling at each other. "You'll give me a heart attack one of these days," he said. "Worse ways to go," she replied.

⌘ 7 ⌘

The Christmas Party

John's stomach was in a knot all day, he was that excited. The atmosphere in the office was gay, befitting the lead-up to Christmas and the annual office party, even though there were still two more weeks to go until the holidays. He sat at his desk and every once in a while slipped his hand into his left jacket pocket to feel the little jewellery box that was there. It contained the ring he was going to offer to Milly that evening, at the party.

Milly worked at the car dealership just down the road and John had met her last year when he changed his Ford for a newer model. He had shyly asked her out, waiting for her inevitable excuse that she was washing her hair or in any case had better things to do. But his Mum had always said, "If you don't ask, you won't get," so he asked anyway and was speechless when she said, "Thanks, I'd like that."

Milly was petite and wore her chestnut hair piled up on her head, no doubt to make her look a bit taller, and her neat little high heels were probably worn for the same reason. John thought she was the prettiest girl he had ever seen (not counting films, of course) and couldn't believe his luck that she had agreed to go out with him.

He took her to the new Chinese restaurant that had opened in the High Street. She seemed to like it and the evening was a great success, her chocolate-coloured eyes appreciative and her lips turning up at the corners. John, who considered himself rather ordinary looking, lanky

and ginger-haired, and who was painfully shy in social situations, found himself opening up and talking quite expansively in Milly's company.

"So what do you do, exactly, at that insurance company?" she had asked him over the spring rolls. Instead of just shrugging and saying, "Nothing much, really," as he would have answered his mother's friends from the Church Group, he said, "I'm just a trainee at the moment, but I want to sign up for the broker's course next year. Then I'll be able to work in any of their branches and earn more money and - who knows? - one day I might even become a branch manager."

Milly looked at him admiringly. At the end of their meal, he drove her back to her parents' house and they arranged to meet the following Saturday.

In due course, John met her parents and sisters and she met his mother who lived in Norwich. At the time of the Christmas party, no one would have been surprised if John and Milly had announced their engagement. It seemed inevitable.

Of course, John had invited Milly to accompany him to the party. It would be the first time she met his colleagues although they had heard more than enough about her over the ten months or so of their relationship. After work, John rushed back to his flat, showered and changed into a fresh white shirt, his best black suit and added a bow tie to mark the occasion. He patted his pocket to make sure the little box was there, combed his hair with water to make it lie flat, then set off to collect Milly.

The party was being held in the main conference room upstairs and it seemed that everyone was there when they arrived. Streamers were hanging from light fittings and people were wearing party hats and holding glasses. The noise was considerable but hushed as John led Milly into the room and all heads turned. It's true that Milly looked absolutely stunning, John thought, in a fitted red dress with a wide skirt and matching shoes. Other people must have thought so too because they came up to be introduced and all complimented Milly on her outfit.

The big conference table had been pushed to the wall and was laden with snacks and drinks. Someone put on a record and the dancing began. John looked around at the other party guests, all co-workers

and their wives or girlfriends. They all looked as if they were having a wonderful time and waved over at him from time to time. He saw one or two people on their own, Marie from accounts (she was fifty-eight and a widow) and Paul, a clever key account manager whom John liked but was too shy and inferior in status to befriend.

John decided that he would ask Milly for her hand and offer her the ring in the little meeting room down the corridor. It would be more discreet (just in case Milly said no). He left Milly at the laden table for a few minutes while he went to check whether the meeting room was unlocked and empty. It was and he hurried back to the party to fetch his soon-to-be fiancée.

When he returned to the crowded room, he couldn't see her at first. Then he spotted her over by the window, talking to none other than Paul. They had their heads close together, probably to hear each other better over the noise. But John was shocked to see Milly laughing at something Paul said - she seemed to be laughing with all the intimacy and complicity that she showed when laughing with him. The way she looked at Paul seemed very intimate, far too intimate. Paul had a teasing, flirty look in his eye and, as John watched, he touched Milly's bare shoulder and stroked the fabric of her diaphanous sleeve. Then Milly looked into Paul's eyes and it seemed to John that they were about to kiss.

He stood there transfixed, desperately trying to remember if Milly and Paul could possibly have met on any other occasion. Suddenly, he realised that his dreams were completely dashed. In fact, how could a beautiful girl like Milly even think of marrying someone as ordinary as he was? Of course she was only going out with him while she waited for someone better to come along. Someone like Paul.

He felt completely annihilated. He went over to Milly and, with barely a nod to Paul, pulled her away and out the door. "Milly, fetch your coat. We're going home," he told her.

Milly remonstrated, "But John, the party hasn't even got going yet. Can't we stay just a little longer?"

"No," replied John shortly.

Once in the car, John drove in the direction of Milly's house, feeling

so upset he didn't trust himself to speak. Milly was quiet for a while then said, "Well, that was a wonderful party. Thanks for inviting me."

He couldn't stop himself then. "Yes, I could see you enjoyed it, particularly when you met Paul. I could see that you two were getting along like a house on fire. Perhaps I should have let *him* drive you home." This came out in a rush, even though he tried to hide the bitterness.

To his amazement, after a moment, Milly burst out laughing. "Oh, John. Don't tell me you're jealous - of Paul!" He was stung. She was laughing at him.

"Well, you were having what looked like a very intimate conversation with him. And he had his hands all over you, stroking your shoulder - and you let him."

Milly looked at him for a moment. Then she said quietly, "John, you obviously don't know Paul very well. He's gay, you know. He was just admiring my dress and asked me where I'd bought it. He told me he liked you a lot and wanted to invite us both over to his house sometime. He lives with Dan, that tall man with the arm in a sling. Do you remember?"

John did remember. The relief he felt knew no bounds. As he drew up outside Milly's parents' house, he felt in his pocket for the little box. Now would be as good a time as any.

⌘ 8 ⌘

Day of the Dead

The alarm went off at four. The first thing I did was listen for the rain before opening my shutters to confirm what I had heard. It was black and silent as the grave outside with slick cobblestones under the yellow murk of the streetlamps. There was no traffic and I knew that Babbo had already left.

The familiar, comforting aroma of coffee came from the kitchen with the gurgling of the coffee machine. Mamma was up and dressed already. I took my place at the kitchen table and Mamma placed my coffee in front of me. Piero, my brother, came in too and joined us. We didn't talk except for a mumbled, "Buon giorno."

Today was the 2nd of November, the Day of the Dead, our most profitable day of the year, even more so than Valentine's Day or June when we sold bridal bouquets by the ton. It always rained on the Day of the Dead, I don't know why.

When we heard the big van jolting along the cobbles, Mamma leaned out and waved then closed the shutters. We all collected our bags, zipped up our ski suits, pulled on woollen hats and padded Goretex gloves and stepped into our Moon boots in the hall. I grabbed my Renaissance Architecture textbook and followed Piero down the two flights of stairs and into the street while Mamma locked up. We piled into the van and I had to sit on Mamma's knees because there was really only room for three on the front seat, especially with our ski clothes on.

As Babbo pulled away, he glanced at my book and said, "Don't

think you'll have time for that today." He smiled and we drove off, through the deserted streets, rattling when there were cobbles then just swishing through the rain, up into the hills to the cemetery of Trespiano, that was as big as a town, people said.

We had our space there, a prime space just outside the big gates, and Babbo edged into it. Ferdinando was already there and his wife Sonia waved over at us, making the usual comment of how it always rains on the Day of the Dead.

The bar on the other side of the road was still closed, of course, and wouldn't open for at least another couple of hours. It was still black but we could see by the light of a wrought iron streetlamp hanging over the bar. Babbo and Piero turned the handles at either end of the van and slowly the canvas canopy squeaked out to cover our space. Then Babbo swung the big back doors of the van back, secured them and work began.

First we slid out the iron trestles and plywood planks of different sizes and lengths and started to fit them together to form a long table in the front, a shelf underneath for the cashbox and wrapping paper and plastic bags, then the bank of shelves behind. Piero and I did most of this work in accustomed silence while Mamma prepared the cashbox and Babbo had a smoke by the gates. Once the stand was assembled, Piero and Babbo and I climbed into the back of the van and hauled down, one by one, the heavy buckets of flowers, mostly carnations, which Mamma arranged in order of colour and height on the shelves.

Because it was our busiest day, the van was filled to the gunnels and it took us over an hour and a half until everything was in place and I was sweating in my ski suit as I arranged the last plastic buckets of flowers on the shelves.

As the first grey glimmer of dawn started breaking to the east, the twin lights of cars started trickling down the winding hill road towards the cemetery making for the town below, some stopping with two wheels on the opposite pavement to wait for the bar to open.

A handful of early arrivals under umbrellas had begun to gather at the cemetery gates and another van drove up and manoeuvred into

place beside us. Finally, the metal blind of the bar was raised with a noise like thunder.

Piero and I crossed the road, leaving Mamma and Babbo to make our first sales. The bar already smelt of wet dog. The espresso machine hissed as we leant on the zinc counter to sip our espressos and eat a maritozzo with cream.

When we got back to the stand, there were the usual four or five vans parked along the road, all waiting to claim the one vacant space at the stroke of eight. It was old Domenico's spot and we decided that he might not come this year since he was well past retirement. But he arrived at one minute to eight and the waiting vans slowly and clumsily did u-turns on the narrow street and started back to town, relieved to be going home and back to bed.

We were already doing a brisk trade in bouquets, wrapping the stems in cellophane, giving change from the cashbox under the counter and serving the next customer. A vulgar arrangement of red carnations sporting a plastic banner that read "Rest in Peace" or "You are Not Forgotten" was undeservedly popular and by ten we'd run out and the buckets were nearly empty. Babbo had to drive off to fetch more supplies from our storeroom in town.

Finally, at about 11, things started to quieten down and we could treat ourselves to a steaming roast pork roll from the porchetta stand opposite, taking surreptitious bites between serving customers. Then we took turns to nip over to the bar for a small glass of red and Piero and Babbo went for a smoke behind the hedge.

It was past four by the time we got home and peeled off our damp clothes. Mamma sat at the kitchen table and counted the money from the cashbox while Babbo put his feet up and watched a soccer match on TV.

"How did we do?" he asked her. She smiled. "Almost 3 million lire." That must have been about 1,500 euros in today's money, not bad for one day's work.

I went on to finish my degree in architecture while Piero dropped out of school just before doing his final exams. He went to work on the stand so that Mamma could stay at home. Babbo was furious that he

had dropped out but was glad of his help. Anyway there was no work and the kids who finished school and even university had to emigrate to Milan or Turin to find employment, some even going to London. There was no work for architects either, so I ended up working on the stand too and when Babbo retired, it was just Piero and I.

⌘ 9 ⌘
Trial and Sentence

I heard about the possibility from someone at the Rare Diseases support group, the mother of a much older boy suffering from the same disease as my son.

"I don't know if they'll accept your son - he's only three and that may be too young. You'll have to ask your doctor," she said.

So I phoned the paediatrician, Dr Folkes. "I don't think they take children," she said regretfully. "But leave it with me. I'll find out."

My son was born with a sort of eczema all over his body. It's chronic and painful. No one knows what caused it or how to cure it. I have to coat his body in a zinc paste every morning before he goes to school to stop the itching. He has made a friend, Robin, who told me that no one wants to sit next to my son in class or play with him during the break because he 'smells bad'. It's the zinc paste. But if I don't put it on, his skin cracks and bleeds. Some days it's so bad, even with the paste, that he can't walk because the soles of his feet are bleeding. On those days, he has to miss school. I teach him at home then, because he's such a clever little boy and so eager to learn. But I have to work too. My husband left us when he discovered that our son had a rare disease. My husband couldn't cope.

So now it's just the two of us. The woman at the support group told me that a new Orphan Drug was being developed for just this disease. Pharmaceutical companies are subsidised by the government to try and develop drugs, called 'Orphan Drugs', to treat rare diseases that would

otherwise be ignored since not enough people suffer from them to make development of specialist drugs profitable.

I didn't sleep much the next two nights, turning over in my mind what it would be like to find a cure. It would change our lives. There would be no more zinc paste, no more stays in the hospital to try to alleviate the pain and heal the lesions. And my son would be able to run and jump and play like a normal boy. He wouldn't be ostracised and he would be invited to birthday parties like the normal kids.

Then there was the financial aspect. I could get a better job because I wouldn't have to take time off all the time to look after my son when he can't go to school.

And best of all, he may have a future after all. Right now, the doctors say we shouldn't expect him to live much beyond 21 years old. My son knows. I told him because 21 is far enough away for him not to worry too much about it and accept his sentence gradually as he grows older. Better than lying. We have too little time together to spoil it with lies.

The thing is, we just don't know. No one knows. That's why I go to the support group every Thursday evening. The not knowing is one of the hardest things to bear. With other illnesses, the doctors can tell you more or less everything: what to expect, how long the treatment will last, what the symptoms are, what alternatives there are if a particular medicine doesn't have the desired effect, etc. But with rare diseases, no one can tell you anything. And there aren't enough people with the disease for the drugs companies to invest in searching for a cure.

But now there might be a chance. The woman at the group told me that a drugs company in France received financing from the Téléthon fund-raising drive and has developed a drug that might work on this type of chronic eczema. They are screening patients to take part in Phase I of the clinical trial at the city hospital.

They don't usually accept children in clinical trials because a trial is what it says: it's a trial and the outcome isn't guaranteed to be positive. Sometimes the patients who take part end up very ill indeed and sometimes they even die. The drugs companies don't like to publicise these adverse outcomes, obviously. But I know they happen. Nevertheless,

sometimes the drug actually works and the people taking part in the trial are the first to benefit.

I'd be over the moon if the drug worked, if my son could only take part. I wouldn't consider the possible adverse effects. He has so much more to gain than to lose. I want him to benefit now, while he's still young enough to enjoy his childhood like a normal boy. Even if the drug is successful, it won't be approved for sale to the public for at least 10 years after it has been tested in trials. That's why I want my boy to benefit now.

So we have a trial and a sentence. The phone rings. It's the paediatrician. My hand shakes as I lift the phone to my ear but my voice is steady when I answer.

⌘ 10 ⌘

A Fresh Start

It was New Year's Eve. The family had just finished dinner and Jake, the fifteen-year-old son, was helping his mother clear the table. The 17-year-old sister, Kate, was fiddling with her Smart Phone as usual, scowling. Harris, hunched over his coffee, watched his daughter surreptitiously, regretting the silver rings in her eyebrow and one nostril, the studs in her ears, the clunky rings. If only she would dress decently, in a more feminine way, she would be quite stunning. But that ugly pancake makeup, the black lipstick and nail polish, those ridiculous army boots... Harris sighed. Where had they gone wrong? Their son, Jake, was working hard at school, was open and friendly, clean-cut and well turned out. They were so proud of him. But with Kate, something had gone wrong. She was rude, uncompromising, unaccommodating. Her schoolwork was barely sufficient. Harris never saw her with a book in her hand, only with earphones hanging from her ears, repulsing any attempt at conversation.

"So where are you going tonight? Party?" he asked her at last with forced jollity. The scowl deepened but the black-painted eyes remained riveted on the little screen and the ring-encrusted fingers continued tapping.

"Yeah," came the laconic, reluctant reply.

Rising to fetch the brandy bottle, Harris sat down again and poured himself a snifter. Usually, he would have waited for his wife but he could hear her washing dishes next door. He found himself wishing his kids

would just push off so that he could stretch out in front of the television and have his house to himself.

Jake came through, set the salt cruet back on the sideboard with the oil and vinegar and started back to the kitchen with a salad bowl and two empty glasses.

"So where are *you* going tonight?" Harris tried again.

Jake paused in the doorway. "I'm going over to Eric's. His brother is picking me up at half past nine. Oh!" he said, glancing at the clock over the door. "I'll have to get ready or I'll be late!" He skittered into the kitchen, came out again and hurried down the corridor to his room.

Kate stood up abruptly and disappeared towards her room too, without taking her eyes off her phone.

When the doorbell rang a little later, Harris swung his feet off the coffee table, muted the TV and went to answer. "Jake! Your lift is here," he called, ushering a young man of pleasant and responsible appearance into the hall.

Kate arrived, now dressed in a tarty-looking bright mini skirt, off-the-shoulder black T-shirt with an orange bra strap showing. "Hey," she said to the newcomer by way of greeting.

"Hey," he replied.

"Umm, can you give me a lift to Rochester Road?" she asked him.

"Yeah, sure."

"Is that where your party is? Rochester Road? That's Elizabeth's house, isn't it?" queried Harris hopefully. Elizabeth wore pearls and had manicures.

"Yeah," mumbled Kate.

Eventually, Jake came along, smart and spiffy in a new Pringle sweater and navy overcoat.

"Take scarves, wrap up warm," said their mother, bustling out of the kitchen. "It might even snow tonight." With a hand on Eric's brother's forearm, she urged prudence. "I'm sure you drive carefully but it's New Year's Eve - watch out for the others on the road."

"And be back by half past one at the latest. I don't want to have to worry about you," Harris said as they bustled out the door in their woolly hats, scarves, gloves and coats.

Phew! Harris exchanged a smile of relief and parental indulgence with his wife then they went into the sitting room and flopped down gratefully on the sofa to watch the New Year's celebrations in countries around the world.

"I do hope that Kate grows out of this phase soon," sighed her mother.

"I know," replied Harris. "If only she could be more like Jake. We've been lucky with him, I suppose. Still," he went on, taking his wife's hand, "it's never too late to make a fresh start."

In the car, Eric's brother drove sedately around the corner and parked in a dark spot between two streetlights. He kept the engine idling as Jake nipped out of the car, up a driveway and could be seen talking for a few minutes with a boy in the doorway of a large house. Something exchanged hands. Then Jake was back.

"Thanks," he said to Eric's brother, whose name was Marcus.

"Never mind thanks. Just give me my cut. Where to next?"

As they drove around and made three other deliveries in the area, Kate sat, eyes glued to the screen of her phone, tapping out messages. Beeping noises could be heard from time to time as messages arrived. Finally, the last delivery was made, the last zip-lock bag pulled out of Jake's pocket, handed over under a porch light, and it was time to settle up.

While Jake and Marcus, heads close together in the front seats, counted out the money, Kate looked out of the misted car window at the brightly lit houses. She felt that tonight would mark the beginning of a new, sophisticated and moneyed existence. She and Elizabeth had signed up with an escort service just the week before and had a busy schedule ahead of them tonight. They had finally decided to turn over a new leaf in the New Year and become professionals, so that they were paid for what they had been dispensing for free up until now, which she now considered as her apprenticeship or vocational training. But now she was ready for the real thing. It was never too early to make a fresh start.

⌘ 11 ⌘

The Second Marriage

The second marriage should have been a doddle. After all, you went into it with your eyes wide open. When the first marriage started to show signs of wear and tear, then eventually fell apart altogether, it wasn't as if she'd left you in the dark, wondering what on earth you'd done wrong. She'd told you, not once but a hundred times, exactly where, how and why you hadn't measured up. So all you had to do in the second marriage was not do all the things you'd been criticised for in the first marriage. No?

Well, the second wedding went off all right. You certainly avoided making all the mistakes you'd made the first time around. The second time, you only had a handful of guests, all really close friends. No family except for her sister, which couldn't be avoided. Getting married in Australia helped. Even with the airfares, it turned out to be cheaper than the first wedding, with over two hundred guests and a marquee in the garden.

But what the hell happened to the *second* marriage? You followed all the instructions from the first time around, even though it cost you considerably. Some things, as she had said, were just bad habits, like resting your feet on the Perspex coffee table so that your size 45s blocked half of the TV screen from her sight. In the new house you bought for the second marriage, you insisted on having two matching sofas so you could lie on one with your feet up and she could lie on the other.

Then you had learnt from the first marriage that you weren't

supposed to leave the lavatory seat up. Women didn't like it, apparently. That was also just one of your bad habits that you made every effort to correct in the second marriage. And wearing the same socks for several days in a row. If she wanted to spend her life running the washing machine, that was her lookout.

So altogether it couldn't be said that you didn't make every effort.

Then there was the other side of the coin, the things that women did that irritated you, like nattering on the phone for hours with their sisters or mothers or best friends. Natter, natter, natter, while you were trying to watch the latest David Attenborough on penguins in Siberia. No wonder you were ill-informed as you had been told a million times during the first marriage.

But you weren't going to fall into that trap in the second marriage. You weren't going to lay yourself open to accusations of always complaining, of not wanting her to have A Life Of Her Own, of being jealous of her friends and family. So you bought yourself a fancy flatscreen TV with surround sound and set it up in the garage. As time went on, you eventually moved the second sofa into the garage as well.

You thought you were clever, avoiding friction. When your best friend Pete came to watch the game, you could both hole up comfortably in the garage and watch without interruption. In the beginning, she used to bring you beers and crisps but you could see she began to be irritated, especially during the season when there was a game almost every night. So you solved that one too and installed a butler's pantry in the garage, with a fully-stocked bar and fridge.

She moaned about one car always blocking the other in the driveway but you nipped that one in the bud by parking in the road. No problem.

When her mother or sister came around, you were polite and considerate. You made small talk and poured drinks. You never denigrated her in public, which was a frequent complaint, as they all were in the first marriage. You complimented her on her erratic cooking and never told her that she looked terrible when she came back from the hairdresser with her hair that peculiar bronze colour. You brought her flowers on her birthday and took her to dinner at the French restaurant on

Valentine's Day. You put up with her inane chatter for hours on end then escaped to the garage when it irritated you beyond all measure, instead of losing your temper, which you had often done in the first marriage.

But now, she was complaining that you spent too much time in the garage. She didn't like the fact that you had installed a shower in there. "The place looks like a tip," she sneered, the last time she visited in the autumn. That was before you'd had the wood-burning stove installed and had locked the door so she couldn't come in. "It's for your own good," I told her. "You only get upset when you come in here. So don't come in. You have the rest of the house to yourself." For some reason, she wasn't happy about this and I couldn't understand why.

Since I've been living pretty much full time in the garage, I've had time to do quite a bit of thinking. I've tried to understand where I went wrong. The second marriage is also on the rocks - she's demanding a divorce on the grounds of 'cruel and inhuman treatment', would you believe it. I hardly ever see her so I don't know where she gets that from. But, with two marriages gone pear-shaped, I am forced to conclude that perhaps I'm not cut out for marriage. And this is difficult to admit, but perhaps I'm still at fault even though I've made all these efforts to make things work. But there are two things I might have failed to consider. One is that I probably made a mistake marrying the same woman twice. If I'd married someone else, I might have stood a chance. And also I'm beginning to realise that I like living in the garage. I like living on my own.

⌘ 12 ⌘

Mid-Life Crisis

Looking around my sitting room, I noticed the yellowing corners of the walls, the worn chair arms and the ugly knick-knacks in the corner cabinet my grandmother left me. Perhaps, now that the last child had left for university, it was time to do something about the decor. I'd really rather have a pale yellow colour scheme in here. If I painted the walls yellow, then I could re-cover the two armchairs and sofa in something gayer, perhaps a Sanderson linen. Heaven knows what that would cost. I'd have to go onto the Internet to check. Then there's the kitchen. I'd had it redone when we moved in twenty years ago but now it looks dated and that black-and-white tile floor was a bad choice. It showed every scuff mark and I was forever sweeping and mopping after myself.

But now that that only Mark and I were in the house, I could manage it. So I started looking and finally found a fantastic pale blue fabric with a green, rust and yellow floral pattern that would look really stunning for the sitting room suite. Then, if I got rid of Granny's corner cabinet, I could buy another bookcase for that corner. That would mean I could clear the extra books out of the shelf in the bedroom....

⌘

Mark came in from the garden where he had been raking leaves and pulled off his wellies just inside the kitchen door. He found Anne sitting

on the sofa with her laptop. She didn't even look up as he padded over to the music centre in his socks and pushed a Rachmaninov CD into the slot. As the music swelled, he sank down into a large armchair and closed his eyes, his hands crossed over his stomach, and thought how great it would be if he opened his eyes and found Adele sitting in front of him, her sleek legs tucked up under her on the sofa, instead of Anne who, he was sure without even looking, was frowning in irritation at the 'noise'.

The last child had left for university last week. Perhaps now was the time he had been waiting for to ask for a divorce. He was so heartily sick of the never-ending routine of the same old meals, the same conversations about the need to change the kitchen floor and the covers on the sofas and whether they should go to the Chinese on Friday nights, which is where he wanted to go, or to the Japanese which was what Anne preferred. They had absolutely nothing else to say to each other any more. While the children were around, the coming and going and the riveting events of their lives made the house sound as if a family lived in it, a singing and dancing kaleidoscope of activity and communication and doors slamming. But he and Anne on their own had nothing left - the glue had come unstuck.

⌘

I wish he wouldn't put on that Rachmaninov all the time. I'd give anything for some peace and quiet. How can I concentrate? All he wants to do is fiddle around in the garden or garage then flop into that chair and monopolise the room with that blaring noise.

He has absolutely no sense of initiative. All he talks about is the kids or where we should dine out on Friday nights. At least I have a full and interesting life even without the children. If I can pull off this redecoration project, who knows? Perhaps I could get commissions from friends and neighbours to redecorate their houses. Then I've got my painting class on Mondays and my Creative Writing on Wednesday mornings. And then, of course, I clean the house and cook healthy meals and shop at the organic market. It's important to maintain standards, I feel. I've

always done it for the children but now that it's only the two of us, surely we should make an effort. It would be all too easy to let things slide, slop around in our pyjamas all day, not even get out of bed, letting the house go to wrack and ruin.

Which reminds me, the meat sauce for the lasagna should be ready by now. I'll just go and turn it off then I can start the besciamella. I'm making three trays so I can put two in the freezer for when the kids come home. Oh damn. I've scuffed the kitchen floor again.

⌘

Mark watched her under his lids. There she was with the broom again. This just isn't a life. The whole house reeks of meat sauce and he doesn't even like lasagna. He closed his eyes again and let himself drift into a daydream of Adele undressing slowly in front of him in a candle-lit bedroom. She hadn't done it yet and, to be quite realistic, she probably never would, given that she was happily married and still had kids at home. But if it wasn't Adele, it would be someone just as beautiful and come-hither. Perhaps he ought to join one of those Internet dating sites, just to see what his chances were before actually asking for the divorce.

A crashing of pots came from the kitchen as Anne banged around. He was tempted to turn up the Rachmaninov to drown out the domestic cacophony but felt it would be too obviously competitive so ground his teeth instead. That did it. He would definitely ask for a divorce tomorrow when they went to the restaurant.

Oh, the delight of living on his own again! The peace! He'd get a flat in town, low maintenance, close to the bars and night-life. He was sure the kids would understand. Actually, he was sure the kids couldn't care less. They had their own lives now. He began to feel distinctly light-hearted and a smile played about his lips as he pictured himself wondering down to the river, seeing a beautiful girl leaning on the parapet, sidling up to her and saying....

⌘

"Oh, hell. There's no more room in the freezer! *Now* what do I do with these two extra dishes of lasagna?"

(His eyes snapped open, an answer almost springing unbidden to his lips. Almost.)

You see, if I redid the kitchen - or rather, *when* I redo the kitchen - I'll have a bigger freezer put in. I could transfer the pantry cupboard into the garage then there'd be room. In the meantime, I'll just have to ask Mary next door to store the lasagnas for me. She always has room.

Now, if I sit just here on the sofa, I can picture what the walls will look like with a fresh coat of paint. Lemon yellow, I think. Then I could scour the art galleries and find some new paintings. Something really striking that would give the room personality. They mustn't clash with the floral chair covers though. I'd have to be careful of that.

⌘

Without opening his eyes, Mark asked casually, "Shall we try the new Mexican place tomorrow night?"

He knows I don't like Mexican food. "No, I'd really rather go to the Japanese if you don't mind."

Or then again, I could try a pastel stripe. That would make a nice change.

⌘ 13 ⌘

Sensory Perception

This evening was going to be dedicated to the senses. Leila had finally agreed to come to dinner with me! It had been a long shot - all the guys at the station had been ogling her from the moment she came in until the time she was released. Then, I don't know what possessed me, but I asked her if she'd like to come to dinner with me and she said, "Yes"!

So I set about preparing for what I hoped would be the most elegant and satisfying evening ever. No detail would be left to chance, no refinement neglected. It was my day off and I was plying the street market with my shopping trolley before the stall-holders had quite finished setting out their produce for display.

I had decided on just two amuses-bouche to start, some crisp celery boats topped with wild Scottish smoked salmon atop a dash of crème fraîche mixed with a little lime juice as a sharp counterpoint to the cream, then I thought a spoon-shaped slice of red endive stuffed with a mixture of mascarpone and a touch of gorgonzola and topped off with chopped walnuts. I would serve the inimitable pink Ruinart champagne that I had been saving for just such an occasion.

I was lucky - the mushroom seller had some aromatic porcini mushrooms, perfect for my soup. I bought the other ingredients and was home by ten, just in time to catch the latest news and put my feet up for a couple of hours before setting about preparing my food at the big kitchen table.

At which point my mother phoned. "Darling, what are you doing this evening? I hope you're not messing about with that silly policeman's job again. Uncle Ralph is coming to dinner and you really should be there. You need to discuss the situation with those stocks..." She droned on for a while and I pressed the microphone button on my phone and left it on the table while I went out to the terrace to collect some rosemary, sage and thyme from my herb garden. I had made the flaky pastry for the beef wellington the day before. I set about chopping the herbs and garlic with half an eye on the TV as mother went on and on with her unilateral conversation.

"What's that noise?" she said suddenly as I banged my chopping knife against the board briskly.

"Someone at the door," I improvised. "Call you back."

Then I made a paste of the herbs and garlic and a slice of the best duck demi-cuit foie gras. I rolled out the pastry and spread my herb paste over it then, after lightly seasoning the beef, rolled it up and basted it with beaten egg. It would be slipped into the oven as I was serving the hors d'oeuvres.

I retrieved my decanter and decanted the wine, a divine Brunello di Montalcino that I had been saving in my cellar for several years, an excellent vintage and just right for the fillet. And to accompany my mushroom soup, I popped a bottle of subtly structured Cabernet Blanc into my wine refrigerator.

Then it was time to chop the shallots and simmer them gently in a knob of butter before adding the carefully cleaned porcini mushrooms. As the mushrooms cooked, I added a drop of Marsala and, of course, some chopped thyme and garlic. After stirring in a little cornflower, I added chicken stock until the mixture was just right. The rich cream would be added at the last moment and with some fresh thyme for decoration. I wondered whether to make some croutons for texture then decided against it.

Mother phoned again. "Darling, about dinner tonight..."

"Sorry, mother, can't make it. An important case has just come up at the station and I absolutely have to be there." I cut us off as she was

moaning about all the time I spent 'dabbling' in police work when, as a multi-millionaire, I needed a job like I needed a hole in the head.

Back to the business in hand: a Pavlova for dessert. I whipped up some egg whites with sugar and a dash of white wine vinegar, piled the mixture onto a baking tray slipped it into the oven at a gentle heat. While it cooked, I made my lemon curd with the yolks, stirring slowly as the mixture thickened. Once the meringue was cooked and had cooled, it was filled with the lemon curd and stashed in the fridge. The cream would be whipped at the last minute, while Leila was relaxing after our main course, and the Pavlova would be served decorated with toasted almonds and raspberries. Perhaps some mint leaves for colour? Hmmm...

Now it was time to decorate the table. My best double damask tablecloth, crisp and smelling of lavender from the laundry cupboard, was whisked out and set in place. The glass coffee table was polished and silver bowls of pistachios and Moroccan olives were set in place. My best Stuart crystal glasses were lined up on the sideboard ready for the different kinds of wines. The lighting, always of crucial importance, was carefully adjusted with the dimmer switch. Candles were set in place to be lit at the last minute.

She was due in exactly an hour, I realised, glancing at my Rolex. Just time to cobble together the two hors d'oeuvre I had planned and set them out on the coffee table in silver dishes. Then it was a rush upstairs to shower and change into my dinner jacket, dress shirt and a bow tie. Oh Lord! I forgot the flowers!

A dash downstairs and a rather rushed arrangement of deep red, grey and white blooms in a crystal vase appeared on the sideboard. I stepped back to admire the stage for the romantic evening I was planning. Music! Darting to the B&O, I dithered for a moment. Vivaldi would be too lift-like so I ended by choosing a J.J. Cale and Nina Simone collection, adjusted the sound then stepped back once again.

The room looked like a film set. The crystal glasses and silver sparkled in the soft candlelight. My best Royal Doulton crockery graced the table in elegance. The sliding glass doors to the penthouse terrace were open to the caress of a summer evening and the sound of waves

lapping on the beach merged with the seductive tones of gentle jazz subtly immersing the room in mood.

My crispy celery boats and creamy salmon antipasti combined crunch, melt-in-the-mouth and tartness to just the right degree, I felt. The aroma of the porcini soup made my mouth water in spite of having worked in the kitchen all day, which usually ruins my appetite.

The phone rang and my mother's coiffed head appeared momentarily on the screen then vanished just as quickly as I turned the darned thing off. As the doorbell rang, I slipped the beef Wellington into the preheated oven and pressed the button in the hall to let Leila in, adjusting my bow tie and cuffs as I waited by the lift doors.

Leila emerged, looking absolutely ravishing in a leather mini-skirt, enticingly low-cut leopard print top and those gorgeous blond locks. Her huge doe eyes were cleverly made up, the lids slightly lowered under incredibly long eyelashes. Her ripe red lips parted in a seductive smile. My hand was shaking as I took hers and bowed over it before ushering her to the sofa. I noticed her amazingly long legs in their patterned black stockings and high-heeled boots.

I could hardly believe my luck! How could someone this beautiful have agreed to dine with me? I wondered what she had been doing at the police station when I met her coming out but when I asked her, she said she was helping the police with their enquiries. I forgot to ask what enquiries they could be but I was sure she must be one of those experts that the police called in from time to time.

"Nice place you have here," she remarked looking around. "Must cost you a pretty penny."

I didn't know what to say so jumped up to fill our glasses with champagne. She sniffed the air, wrinkling her nose. "Hope you're not making mushrooms. I'm allergic." My heart sank. But never mind, we could have the hors d'oeuvres then move straight on to the main course which was browning in the oven as we spoke.

She took a sip of the champagne and I was sure that her indifferent expression reflected her worldly experience of drinking champagne regularly. How could I keep up with someone like her?

Suddenly, she leant over and placed her hand on my knee. It was

a warm hand, a *very* warm hand, adorned with long scarlet nails that reminded me of an ancient Chinese print of a mandarin that I had in the guest suite. She stared right into my eyes, her own partially hidden by the considerable overhang of jet-black lashes.

"Darling," she oozed in a throaty voice, "why don't we go to McDonalds over the road? It'll save you the work and .." - the eyelashes batted and the smile was slow and incredibly irresistable - "...your energy. We'll finish the champagne when we come back, shall we?" The long-nailed hand with its promise of vice crept a little way further up my thigh and her rotating backside mesmerised me as I followed her to the lift, leaving the beef Wellington to its own devices.

⌘ 14 ⌘

Something Stupid

They made me sit on a hard wooden bench outside the courtroom door. Andrew was in there now, being grilled. The boy was in the hospital. Lawyers in black hurried past me in twos, carrying files and talking earnestly. I looked at the floor and thought about what had happened.

When the boy was born, we were so happy. But he cried and when Andrew came home and heard the crying, he'd clench his jaw and slam out of the flat without a word. I knew he went to the bar on the corner and felt sorry for him, realising he was exhausted after a hard day's work and understanding his irritation.

Once, when the boy was older, about two, he wouldn't have his bath, screaming and shouting, "Won't! Won't!" Suddenly, Andrew was in the doorway.

"I'll take care of it," he said and steered me into the next room then, returning to the bathroom, he closed the door after him. I heard a scream and half rose out of my chair but Andrew came out and gently pushed me back down. "Don't worry, he won't do that again. He did something stupid and now he knows." I saw the bruises on the boy's arms and legs but was relieved he had learnt his lesson. Andrew knew how to discipline the boy and I didn't.

But sometimes Andrew went too far, at least I thought so, but of course I didn't like to say. Like that time when the boy went to the shops to buy a packet of sugar and didn't come home for an hour. When he

finally rushed breathless into the kitchen, he told me he had met some friends and they had been talking about Star Wars but Andrew was onto him like a shot. Took him into the bedroom and closed the door. No screams that time - the boy knew it was no use. I just drank my tea and waited. The boy was never late again.

In the evenings, when I went to tuck the boy in and read him a story, he kept asking me to read it again or read another story, taking longer and longer to settle down. When Andrew came back from saying goodnight to him, he kissed me, saying "You've done a good job with that boy." He was such a good husband.

But one night, the boy kept clutching at me and wouldn't let go, insisting that I read him another story. I was exhausted and just wanted to get it over with and I'm afraid I lost my temper and shouted at him to go to sleep. I switched off the light and stormed out. "Tell him to go to sleep. He won't listen to me," I snapped at Andrew. Which he did, but it took some time. I was smug.

Sometimes, I'd wake up in the night and hear a scream from the boy's room but the other side of the bed was empty so I knew that Andrew was taking care of it. "He had a nightmare," Andrew said when he came back. So I turned over and went back to sleep.

The boy became sullen and didn't work at school. The teacher would call me in and question me about it. I told her that the boy must be going through a difficult age. "Are you having any problems at home?" she asked.

The impertinence of it! "Oh, no," I said.

Andrew was gentle and loving with me and firm with the boy. I noticed bruises on the boy's arms and legs from time to time but nothing that couldn't have been the result of horsing around in the playground. And the boy never complained. But he hardly spoke at home and always had his nose in a book.

Then suddenly everything fell apart. The boy was sick and I had to call the doctor. Andrew was still at work. The doctor saw some bruises and virtually interrogated me. I told the doctor that the boy probably got them from the other kids in the playground. The doctor asked me to leave and shut himself into the bedroom with the boy.

"Is he alright?" I asked anxiously when the doctor eventually came out.

"Just a touch of flu," the doctor replied and left without staying for tea.

The next day, a man and woman arrived on my doorstep. They said they were from social services and were taking the boy to hospital. I couldn't believe it.

"Is he that bad?" I asked.

"We'll see," they said. So I packed a bag and they took him off in an ambulance. They wouldn't let me go with them but said I could visit the next morning.

Andrew was furious when he came home from work. "How could you let them just take the boy like that?" he fumed. "No one goes to hospital just for a touch of flu."

"Perhaps it's worse," I suggested. But Andrew insisted we go to the hospital immediately and bring the boy home.

But at the hospital, they refused to let us see the boy. They told us we'd have to return the next day. But the next morning, before we were even ready to leave, two policemen came to the door. They said they needed to take Andrew down to the station for 'questioning'. I thought it was about the bruises. Or perhaps even a case of mistaken identity. So I hoovered the carpet while I waited for him to come back.

Instead, they phoned to say that he wouldn't be coming back. He was being held in custody for mistreatment of a minor, and perhaps even more. I was totally in shock.

As soon as I had gathered my wits about me, I rushed off to the police station and demanded to speak to someone in authority. "This is ridiculous! You're holding my husband in custody for something he didn't do!"

But the sergeant was adamant. Andrew was to remain in police custody until his trial. When I refused to leave, a captain was called, a lady captain. She was kind and offered me a cup of tea in her office but I was too nervous to accept. She said that Andrew had admitted to violent behaviour against the boy.

"What rubbish", I said. "He was never violent. He was just strict,

that's all. If the boy misbehaved, my husband punished him. That's all. Just like any father would do."

"Not quite," said the captain, looking at me strangely.

Anyway, I had to go, to visit the boy in hospital. He seemed fine to me although he looked thin and pale which was no doubt due to the hospital food. He smiled when I came in but then immediately peered over my shoulder.

"Is Dad coming?" he asked in a small voice. When I shook my head, he seemed relieved and held his arms out to me. In fact, he cried and cried on my shoulder, I assume because he was so pleased to see me, although his reaction seemed a bit excessive.

"Don't worry now, my love," I said to comfort him. "Dad will be in to see you soon. He's just helping the police with their enquiries."

A doctor came to see me and asked me some peculiar questions about the bruises and so on. I just told him what I knew. Then he said that he would be keeping the boy in the hospital for a while longer.

"Can't I take him home with me? He'd like to be home, I'm sure," I said. But the doctor said that if the boy left the hospital now, he would be taken into care by the social services, at least until the court case had finished. I couldn't believe my ears - what was the country coming to, with children being separated from their parents? Taken away, even.

So I went home on my own. And eventually, the court case began and here I was, on that hard bench, being beckoned to by a clerk.

"You're on now", he said, and I went in.

Andrew was sitting in the front row and I smiled reassuringly at him but he didn't smile back. He looked away. Perhaps he was embarrassed to be seen there, which was perfectly understandable. I swore on the Bible to tell the truth then sat in the witness box. I was nervous but determined to tell the truth to save my Andrew. A couple of times, the judge had to ask me to speak more loudly. It's true I was intimidated. But I told them about the bruises, that Andrew was only disciplining the boy, making sure he wouldn't end up a hoodlum.

But gradually, they asked me about other things, shouting at me, bullying me. I cried. I was confused and the crime they thought Andrew had committed was slowly dawning on me. All the truthful answers I

gave them seemed to support their theory. I panicked. What should I do? It was too late to lie.

I looked over at Andrew then, and he looked at me. He despised me, I could see it clearly in his eyes. And I could also see something else.

So when they asked me, "How could you possibly not have realised, or even suspected, what was going on? How could you have stood by and allowed your husband to hurt the boy? Your son!", all I could do was sob and whisper, "I've been so stupid, I've done something so stupid."

⌘ 15 ⌘

A Warm Spring Morning

It was a warm spring morning but I felt cold to my core when I heard the sirens. I was sipping my coffee in Pietro's bar on the quayside of Lampedusa before going to work at a local NGO where I licked stamps and was occasionally trusted to take the mail up to the post office in the village.

"What's going on?" I asked the bartender. He hurried to the door and shouted to a passing fisherman.

"Apparently a dinghy full of migrants ran into trouble last night. It capsized." He stood in the doorway for a moment then went to turn on the TV on the wall. I didn't wait but ran along the quay to where a group of fishermen were standing, shading their eyes and peering out to sea, in the direction of the African coast.

As we stood there, other people came to join us until we were quite a crowd. We saw the coastguards streaking across the flat sea, sparkling in the morning sun. Then they stopped some way off, little white spots immobile against the hazy African coast.

Doctor Bartolo's car arrived and parked next to the ambulances. He jumped out and stood waiting, shading his eyes and watching the first of the coastguard launches heading back in our direction, laden with people, squashed into the confined space, some shivering in gold-coloured thermal blankets.

I had to go to the office but they told us we could go to the migrant shelter to help instead. There were hundreds of people milling around,

many lying or squatting on the ground outside and a long queue inside awaiting examination by the medical staff. I was told to collect blankets from the storeroom and hand them around, starting with the children and old people. There was a long table and women from the association were handing out food in plastic bowls, the fragrance of minestrone and fresh-baked bread mingling with the overpowering smell of petrol and sea-soaked clothes.

There was a room where people queued for a clean, dry tracksuit and a queue for the inadequate toilets. In fact, there were queues and milling crowds everywhere, the exhausted migrants talking among themselves in Arabic, their common language, but the cacophony was subdued considering the crowds, the people allowing themselves to be herded hither and thither, meekly accepting the aid offered to them.

Many were suffering from dehydration, hypothermia or burns from sitting in leaked petrol in the bottom of the dinghy. There were rumours that the people on board had set fire to a blanket to attract help from the coastguard and other rumours that the dinghy had been deliberately punctured by the traffickers in Libya, knowing that the EU rescue teams would have to intervene.

Then the bodies arrived. There were many children and babies among them. I found a young boy, perhaps about 12, searching each dead face as the bodies were laid out gently in a row. He spoke a little English and told me his name was Sami and he was searching for his parents who had fallen into the sea.

"My mother can't swim," he told me.

At last, all of the bodies that could be found were recovered, some buried in the small cemetery on the island but many discreetly removed to the mainland for burial. There was no sign of Sami's parents.

"Perhaps they were found by a fisherman and taken back to the Libyan coast," the priest told him. You could see that Sami wanted to believe this but the shadow in his eyes showed he was grieving for them already.

During the days that followed, he attached himself to me and helped explain to people that they had to line up to see the doctor then line up to be identified and sorted into asylum-seekers or economic

migrants. He told me he was from Eritrea. "We must work," he explained. "No work in our village. No food." In fact, he was very thin, but seemed strong.

A school was set up for the youngsters and I was roped in to teach them English, more as a distraction than with any official curriculum in mind. English was my native language and I missed hearing it spoken since I had left Johannesburg four years before in a fruitless search for my father's family in Sicily after the sudden death of my parents in a road accident.

I worked at the Centre for a couple of months, the numbers of inmates gradually thinning as they were shipped northwards or to other EU countries that had accepted them. The temperature rose as summer took a grip on the dusty island and my contract with the NGO expired.

I said goodbye to Sami, sad to be leaving him, but the priest told me that there was a chance that he would be adopted by a family on the island. So I reassured him that he would be alright then, and set off by boat and a series of trains for Florence where I had another NGO job waiting.

Several years later, I went back to Lampedusa and hunted out Sami. There was a new priest who knew nothing, particularly as several other influxes of migrants had passed through the island since, but Doctor Bartoli knew where he was and pointed out the house on the cliff.

I thought he might not recognise me but Sami was overjoyed to see me. "I finish school this year then I'm going to be a fisherman like Papa," he told me.

We walked down to the quay and sat on the edge with our legs dangling towards the sea. Shoulder to shoulder, we talked about our luck in having found a home in Italy, a good job and a family of my own for me and a new future for him. But as we sat looking out towards the African coast, in our silences, we mourned our past and the people we would never see again, the sounds of our languages, the wide horizons and smells of our native lands and the homesickness that would always be with us wherever we went and whatever we did.

⌘ 16 ⌘

Taking Sides

"**H**arold, we need to talk."
 I perked up in my basket and, across the expanse of the pale Chinese carpet, I saw her framed in the doorway of the study and immediately knew that something was wrong.

Harold, ensconced in his armchair in front of the fire, rattled his newspaper, uncrossed his legs and twisted his wizened neck in her direction. "Yes, dear? Come in, come in."

"Um, I'll just ask Daisy to bring in the drinks tray. I'll be right back," and she vanished. Harold raised a bushy eyebrow, adjusted his glasses and turned back to his paper.

I padded through to the kitchen, nails clicking on the shining parquet. She was crying when I went in and patted me on the head. Daisy was nowhere in sight.

"You can't imagine how difficult it is for me to make this decision," she sniffled, caressing my ears. "But I just *can't* carry on. I'm very fond of him, you know. But I didn't marry him for love, after all."

She blew her nose on a piece of kitchen paper and poured whisky into two crystal glasses. "I made such a ghastly mistake, marrying a man twenty-five years my senior. And now, all I have to look forward to is… is….looking after *him* in his old age." And she burst into tears again, burying her face in her hands.

I did what I could to comfort her, pressing my nose into her skirt, and couldn't help whining in sympathy.

"I'm still young enough to make a new life for myself," she sobbed. "Why should I stay chained to an old man for the rest of my time on earth?" She fondled my ears and looked down at me. "You're the only one I can talk to," she resumed. "Everyone will think me so ungrateful, so selfish. They'll say, 'Harold gave you everything. He made you who you are'."

She flopped down on a chair, burying her head in her hands, and I planted myself next to her, my head against her knee to show my solidarity.

"Well, it's true enough," she went on in a different tone. "Without Harold, I would never have been able to open the antique shop. I would never have had... all this," and she flung out a hand, taking in the gleaming kitchen and the huge, luxurious flat beyond. "And the cruises...". She wiped her eyes. "I married him for all this. I know. And I got it, so I shouldn't complain."

She sniffed, stood up and moved back to the counter with me at her heels. "And he's a good man. He's been good to me."

At that point, Daisy lumbered officiously into the kitchen, already in her ratty old coat with her ratty handbag over her arm. When she saw Madam, she dropped her bag on the kitchen table and rushed over.

"Oh, Madam, what's wrong?" She swatted at me impatiently with her scarf and I backed off, just a little. One of these days, I'd literally bite the hand that fed me and wouldn't have a moment's remorse.

"It's nothing, Daisy, don't worry, just a moment of weakness. Must be the weather." Madam blew her nose again and turned away, arranging silver dishes of olives and peanuts on the tray.

"*I'll* do that. I'll bring in the drinks, Madam," said Daisy bossily, trying to elbow Madam aside.

"No, no, Daisy, I'll take care of it. You just go off home. It's late. I'll see you tomorrow."

And Madam gave her a bright smile as Daisy reluctantly collected her bag and backed out with a "Well, if you're sure everything's alright...", her eagerness to get back to her miserable flat winning over her curiosity to know why Madam was crying.

The laden tray rattled for a moment as Madam lifted it and made

for the door, pausing just for a moment to whisper down at me, "There's Roberto, you see."

I froze. Roberto? Roberto, the *gardener*?

But she was off again, glasses clinking on the tray, crossing the huge hall and entering the study to break the news to Harold. And I followed, standing on the rug in front of the cosy fire, staring speculatively at my basket in its usual place next to Madam's chair then finally deciding to flop down at Harold's feet.

⌘ 17 ⌘

Lobola

The old maid and the new maid sat side by side on the grass verge, swilling down their doorstep sandwiches with dark tea in tin mugs. It was eleven o'clock on a hot summer's day in the desirable Northern Suburbs. The maids from the opulent mansions behind bougainvillea-laden walls were taking their tea break, sitting in twos or threes in their pastel uniforms, white aprons and doeks neatly tied behind their heads, tatty tennis shoes stuck out in front of them, chatting peaceably in the shade of the plane trees.

On meeting the new maid for the first time the day before, the old maid decided that, rather than possibly losing face by selecting the wrong Bantu language, she would set the tone by speaking in English. So it was in this idiom that the new maid addressed her.

"So what he do, your first son, then?" inquired New Maid respectfully.

"He studying at the university. In England", replied Old Maid proudly. "He won a scholarship".

"Aow!" uttered New Maid in awe. "He one clever boy, that one." She paused to take a sip of tea. "He married, then?" she asked.

"We find him a wife. We find him a chief's daughter", said Old Maid smugly.

"Aow!" said New Maid, suitably impressed. "A chief's daughter!" Then her expression clouded. "A chief's daughter, that take a lot of lobola. She be wanting goats. She be wanting gold".

Old Maid's brow puckered. "Yes, you right, the bride price is a big problem. But I been saving for years and years and now we have goats. Lots of goats. So we think we all ready. But you know what?"

New Maid was agog. "What? What she want?"

"She want a *car*", spat out Old Maid.

"Aow!" New Maid was appalled.

"Well, she not getting a car. She not getting gold either. She getting goats like everyone else," said Old Maid resentfully. Then she added, "She getting more goats though. After all, she a chief's daughter."

"Naturally," agreed New Maid.

Old Maid threw her crust into the road for the birds and decided to change the subject.

"So what you doing?" she asked, tipping her head in the direction of New Maid's mansion.

"Today we cleaning the crystal tchandleer. The one in the dining room. My Madam has crystal tchandleer in all the rooms. Even the cloakroom," boasted New Maid. "And you, what you doing?"

Old Maid reflected. "I cleaning the silver. Madam she have so much silver. Silver cleaning that take days when you have piles like Madam."

A car whooshed past, squashing the sandwich crust and blithely hurtling through the Stop street at the corner without a moment's hesitation before disappearing over the hill.

"My Madam, she have a monk coat," stated New Maid suddenly.

"She have a what?" Old Maid appeared distracted.

"A monk coat," clarified New Maid. "She say it cost a fortune. She keep it in the walk-in fridge in the summer." She swallowed another mouthful of tea, then remarked pensively, "She look like a baboon, going shopping in that coat."

Old Maid giggled, then sighed when she remembered the goats.

The tea break was over. It was almost lunchtime. At their leisure, the maids all along the road heaved themselves upright, shook out their mugs and waved to each other, waddling broad-beamed towards their respective mansions.

In the kitchen, Old Maid settled to her chores, the thought of the chief's daughter rankling. "A *car*, she wants," she fumed.

Some days later, she received a photograph. It showed a handsome young man in a dazzling shirt that matched his grinning teeth. In one arm, he held a pile of books and his other arm was draped over the shoulders of a beautiful girl with an Afro hairstyle, mini skirt and wet-look boots, also smiling into the camera. The couple leant against a blue convertible.

Old Maid turned the photo around to see the inscription on the back: "Me and Tracy, Notting Hill, 1968."

"At least this one not needing a *car*", thought Old Maid sourly. "She already got a combustible."

After a night's reflection, she felt she should do the dignified thing and offer the goats to "Me and Tracy".

"Helen, where *are* you?" trilled Madam's voice from the hall.

"In the kitchen, Mem," trilled Old Maid back. "I cleaning the silver." She hastily picked up her cloth and resumed polishing a pewter beer mug.

"Letter for you, Helen," said Madam, dropping a blue airletter on the table. "From your son, I expect."

When she had gone, Old Maid ripped the airletter into two separate pieces and laboriously deciphered the message. Thankfully it was short. The first piece announced that her son would not be marrying the chief's daughter after all but was planning on marrying Afro Girl instead. The second piece said that he would not be allowed back into the country with his fiancée so was staying in England. He said that Tracy thanked her for the goats but that they would not be welcome in Notting Hill so regretfully she would have to decline the munificent gift.

Old Maid burst into tears. How could he refuse a chief's daughter? A *chief's* daughter, not just anyone, not like this skinny shiny-legged creature in the picture. What shame! How could she tell the chief? It was an insult.

Gradually, Old Maid's muffled keening subsided. She blew her nose on the dishcloth and rallied. Shelling peas, a plan gradually crystallised in her mind.

"Yes! That's what I going to do. Second son must marry chief's daughter. Then the goats not wasted. Aow! I am a genius!".

She hummed as she worked, all her woes forgotten.

⌘ 18 ⌘

Rosa

The twice-weekly bus arrived in the deserted village square in a cloud of dust and juddered to a halt. A young girl alighted, a ratty knapsack over her shoulders, and the bus departed. The girl, who had flaming red hair, long brown legs and wore a cotton dress with bright flowers, looked like a hibiscus in the sun-baked square. She walked over to the fountain, flicked water onto her face and shoulders then looked about her, finally making for the fly-specked curtain under a rusted beer advertisement.

She stood in the doorway, her eyes adjusting to the gloom, until she made out the bar counter and three men in workman's clothes and cloth caps staring at her, as immobile as waxworks. Her smile was guileless and they found themselves atypically smiling back, their grimy claws clutching thick glasses. The girl sat at a formica-topped table, dropping her knapsack at her feet.

"I'll have a beer and - do you have anything to eat?" she called to the barman in a pleasantly musical accent from somewhere else, perhaps the North.

The men at the bar turned back to their beers, muttering amongst themselves and darting glances at her from time to time. She was served a frosted bottle of beer and a plate of chorizo, local ham and a thick slice of manchego cheese with a basket of country bread.

Her hunger satiated some minutes later, she caught the bartender's

eye. "Do you know of anywhere to rent around here?" she asked, adding "Somewhere simple, not expensive?"

The barman confabulated with the men at the bar then said, "Come back at two and I'll take you."

Leaving her knapsack behind the bar, she set off to explore the village. It took her all of ten minutes to take in the three cobbled streets and the dozen-or-so whitewashed houses, gay geraniums hanging from the walls and net curtains twitching. An old lady in long black skirts toiled bow-legged up the street with a heavy grocery bag. The girl offered to help her and the woman, after a moment's hesitation, gave her the bag and continued up the road to a doorway at the end, thanking the girl before disappearing through the plastic fly-curtain into the dark room beyond.

The girl retraced her steps until she found a small grocery shop where she bought a bottle of water under the beady stares of two black-clad women clutching purses and shopping baskets. Then she went back to the bar and sat on a plastic chair in the shade outside until it was two o'clock.

The barman came out carrying her knapsack and closed the wooden door without locking it, and they trudged around the corner and up a cobbled lane that petered out into a dirt track winding uphill until they reached a small stone cottage.

The interior consisted of one square room with a rudimentary kitchen in one corner, a stone sink under the window and a rough wooden table with two chairs in the middle. A big bed stood against the opposite wall.

"The outhouse is in the garden, behind," explained the barman. "There's running water and electricity. It's a good place. Quiet. Just the goats." As she seemed to hesitate, he added, "It's very cheap."

"I'll take it," said the girl, smiling and delving into her knapsack for her purse, counting out the few notes and coins for the first week's rent.

"May I ask your name?" inquired the barman.

"It's Rosa," she said.

Later in the afternoon, as the heat started to abate and the labourers left their olive groves, vineyards and fields for a refreshing drink at the

bar before returning to their homes for their evening meal, a young man snuck up the dirt path and peered through the window of the girl's cottage. A lamp was burning inside and the girl was sitting at the table reading a book.

Suddenly she looked up, straight at him. There was a moment when both remained frozen in surprise then, just as he was about to run off, she smiled her enchanting smile and beckoned to him. He hesitated before complying and never regretted it. The bed was soft and Rosa's arms were welcoming and the young man returned to the bosom of his family with an irrepressible smile playing about his lips.

One day, Juan, who worked in the olive grove behind the cottage, on an impulse decided to deviate on his way to the bar for his evening drink, just to see what the girl was doing. She was sitting on the wall outside her cottage and soon invited him in. He also found her bed soft and her arms welcoming.

After some weeks, the men in the village all had irrepressible smiles on their faces and the dirt path leading to the cottage was well trampled.

In the grocery shop, the women huddled together, whispering.

"My Manuel, he's like a different man," confided Carmela. "He's always whistling and in a good mood these days."

"Mine too, mine too!" exclaimed Maria. "Every evening, when he comes back from the bar, he's sort of... uplifted! And he's so much more...affectionate." She reddened and the others giggled.

"Yes, it's funny but it's ever since that Rosa arrived in the village," remarked Dolores, the shopkeeper. The ladies became pensive, but could not see the link so shrugged and enjoyed their newfound family harmony.

But Dolores's words stuck in their minds and they decided to do some investigating on their own. They peered through the window of the bar but all they saw was a line of men watching the match on the television and sipping their beers, just as they always had. But it gradually dawned on them that one man or another, who was supposed to be in the bar, wasn't.

Then one day Carmela thought she would just climb up to Rosa's cottage and ask her if she knew what was going on. Peering preventively

through Rosa's window, what she saw hit her like a thunderbolt. Everything fell into place - the irrepressible smiles of the men, their furtive absences, their improved mood.

An emergency meeting of the women took place in the grocery shop.

"It's outrageous!" declared Maria.

"She's stealing our husbands!" agreed Carmela. And the general conclusion was that Rosa had to go.

A week later, the barman was reluctantly obliged to inform Rosa that the cottage was no longer available for her and that no other accommodation could be offered in the village. So on Tuesday morning, Rosa found herself standing once again in the dusty square with her knapsack, waiting for the bus that would take her to some other village in some other province where she could carry on doing what she loved best, bestowing comfort and joy to all. And as she was carried away, all the men lined up outside the bar, sad and silent, each with a hibiscus in his hand.

⌘ 19 ⌘
Piña Colada

I met Marie in a family-run restaurant close to where I work and where I usually go for lunch. She asked for the salt and, when I saw her smile and her friendly eyes, I knew that she was the one for me. She agreed to go to the cinema with me then to an exhibition opening at a local gallery and our love blossomed. After we had been going out for about six months, I was given a small promotion in the back office of the bank and decided to upgrade our relationship as well.

First, I moved out of my miserable studio and found a one-bedroom flat not too far away. In the bedroom, the bed was only about six inches from the wall at its foot. I went on-line and, after much searching, found a huge poster of a Caribbean beach and tacked it up on the wall facing the bed. The yellow beach was studded with palm trees and little brightly-coloured cottages on the far promontory. The water was pale pistachio and, as I lay in bed with Marie, I dreamt of walking into it slowly and the silky feel of the water on my tanned skin. Looking down at Marie, I thought how perfect it would be if I could take her to the same beach in the photo for our honeymoon.

Now that I had the flat, I could move on to the next step. I bought a ring, invited her to dinner at the Violaine, which has candles on the table and pretty good food, and popped the question.

But she said, "Paul, it's too soon. I need to finish my degree first, then apply for the bar exam. I just...can't."

"But you're the perfect person for me. I don't want anyone else,"

I blurted, then added, "We don't have to have kids straight away. We could wait for that."

She didn't say anything for a moment. Then she seemed to come to a decision. She left her napkin on the table and said, "Paul, you're not the right person for me. I'm sorry." And she pushed her chair back, collected her handbag and said, "Don't phone me again, Paul. It's over." Then she left.

I was in shock. All my carefully laid plans were shattered. I don't remember going back to my flat or going into work the following morning. At the coffee machine, a colleague asked me if I was feeling all right. He said I looked pale and ought to go home. I said, "No, I'm fine, really," but back at my desk, I couldn't concentrate and kept crying. So I washed my face, made my excuses to my boss and left.

It was freezing outside and my umbrella poked against others as I descended the sleek steps of the metro. In the train, I realised I would have to stop at the doctor's office for a sick leave certificate. I saw my reflection in the metro doors and didn't recognise the haggard eyes. I looked again and saw a tall thin man in a dark overcoat and scarf carrying a briefcase and furled umbrella. In the reflection, I saw other men, all in overcoats and scarves, all carrying furled umbrellas and briefcases, all with dirty shoes, some sitting, some standing, some reading newspapers. I wondered what this peculiar race of beings was, where they were going, and felt like an alien on an undiscovered planet.

I battled my way to the doctor's door through the forest of umbrellas. The waiting room was fuggy with other patients and their germs, the window tight closed to ensure that all inside would be infected. I loitered in the corridor and when it was my turn, I told the doctor I couldn't sleep. He gave me a prescription and a letter for a psychiatrist that I did not need.

I couldn't wait to get home where I could lie in bed, dreaming that I was lying on my back in that soft sea, the hot sun beating down on me and contrasting with the sensation of the cool water surrounding me. I could hear the gulls cawing and, far in the distance, dark-skinned fishermen in straw hats gabbling to each other over their nets in the shade

of their boats pulled up onto the sand. I smelt pineapple and coconut and dreamed of ice-frosted cocktails I had never tasted.

On the third day, I went out into the freezing world, dressed again in my alien's uniform of overcoat and scarf and once again battled along the umbrella-thick pavements to the mouth of the metro. When I arrived at my station, I was swept up the stairs and spat out onto the pavement. Where was I? I had to ask for directions and followed the pointing finger to a blue door with a brass handle.

"Sit down, sit down," the doctor pointed to a chair. Then he just stared at me and I stared back, waiting for him to begin. At last, he took up a pen and began to scribble in his notebook. This went on for fifteen minutes. I couldn't help but think of his astronomical fee for half an hour's consultation.

"Um, excuse me, doctor, but could we get started? Don't you want to ask me any questions?" I inquired.

The doctor looked up sharply and said from a very great height, "We don't do Jungian psychiatry here. We use the Freudian approach. It's up to you to speak. If you have anything to say," he added snottily. I didn't but stayed put for the rest of the session out of spite.

On the way home, I picked up the sleeping pills my doctor had prescribed. It had stopped raining but the sky was lowering and it smelt like snow. I posted my sick leave certificate to the human resources office at work and thankfully returned to the warmth of my flat. I turned the heating up to maximum and just floated in that mint-coloured water. After sleeping and waking many times, I knew that Marie was there beside me, floating in the water on her back with a flower in her hair.

Days went by and I lost all track of time. I turned off my phone because its constant ringing distracted me. I also heard pounding on my door and people calling, "Paul, are you in there?". I wasn't hungry so didn't eat and felt light-headed. I stopped showering until my smell interfered with the iodine smell of the sea so I had to wash in the alien bathroom.

I gradually came to realise that the only thing I really wanted in my want-less universe was to live with Marie in one of those bright cottages on the promontory, basking in the eternal summer of the bay, forever.

Susan Widdicombe

So I took the pills, washing them down with water, until the last glass turned into a frosted piña colada. I clinked my glass against Maria's and, smiling, realised that my dream had finally come true and I was happy. And that's all I remember.

⌘ 20 ⌘

Blind Faith

The assassin's anonymous white van wound serenely along the coast road in the shimmering heat of a June afternoon. There was no other traffic on the road and the assassin raked the hazy distance ahead in search of the lay-bye where he was sure Steve had stopped to answer the assassin's promised telephone call at exactly half-past three. The lay-bye was the only place Steve could stop for miles on this road.

The assassin's eyes flicked to the dashboard clock - half-past three on the dot. He smiled without mirth, picturing how he would arrive in the lay-bye and watch Steve's expression of dawning panic when he saw the gun with the silencer pointing at him through the window of his Maserati. Then the assassin would remove the sports bag with the money from the boot and throw it into his van. It would just be a matter of seconds for him to release the hand-brake of the Maserati, point it in the right direction and both Steve and the car would fly gracefully over the cliff into the foaming sea below.

As the van turned into the next curve, the assassin caught sight of the lay-bye in the distance. He also spotted the red Maserati parked where he expected it to be and smiled in anticipation as he followed the road to the left, with the lay-bye temporarily eclipsed by the mountainside. With one hand, the assassin felt for his gun on the seat beside him and was reassured when he touched the cold metal. No hurry now - this would be a piece of cake. He had nothing against Steve personally but

the imminent assassination was a means to an end - he had to get his hands on the money or he'd be sleeping in the ground before you could say Jack Robinson.

So it was with unbelieving amazement that he saw, as he rounded the next bend and the lay-bye swung into view again, much closer this time, the Maserati creeping slowly but inexorably toward the edge of the cliff. The assassin accelerated then, but he realised that nothing he could do would change the inevitable fate of the car. Apart from the car, there was no one else in the lay-bye. So Steve must have planned a suicide, saving the assassin a bullet.

But then the assassin froze. Oh God! The money! It must be in the boot of the car, and that boot was careening over the cliff together with the rest of the car as the assassin watched helplessly. The Maserati looked like a glittering bright toy as it caught the sunlight and somersaulted once, then again, before plunging into the sea and sending up a slow-motion spray that licked the cliff top and it's slanted information board for tourists at the cliff edge.

The assassin completed the last couple of bends and swerved into the lay-bye. Then he just sat there, his mind a blank, unable to focus on his next move, until his mobile phone rang. He thought about not answering but knew he had to.

"Eric? You there?" came the voice he dreaded. He had so been looking forward to making that call himself, a call confirming that his assignment had been successfully completed and that he had the money in his boot.

"Well, all right, don't answer if you don't want to. I can wait," came the soft voice, now sounding slightly threatening.

"Ginger, I'm afraid it's bad news. No fault of mine, you understand," said Eric eventually.

"What?" Ginger's voice was now definitely threatening.

Eric explained briefly. As he spoke, he realised, with a sickening lurch, that Ginger wouldn't believe him. He would think that Eric had picked up the money and was making off with it. "I had everything taped, I had Steve under my thumb, nothing could go wrong," he blabbered. "I can't help it if he committed suicide."

As he spoke he made his way to the tourist board and blindly stared at the pictures of birds and beasts. He glanced briefly down into the roiling sea but there was no sign of the Maserati and the cliff edge gave him vertigo. The sea was deep here.

Then he had a sudden burst of inspiration.

"Ginger, listen to me! I'll get hold of some professional divers. They'll be able to go down and find the car, open the boot, get the money out. Then we'll just have to dry it out!"

Ginger, dubious, said shortly, "Do what you like, but I won't forget this bungle. You don't come back with the money and you'll be in the presence of the Lord before you know it. *You're* under *my* thumb now." And the phone went dead.

Eric looked at it for a moment, then walked briskly back to the van, jumped into the driver's seat and headed off to find Rick, a diver he had used before on a similar job.

Steve's fingers, curled around the base of the metal stand holding up the tourist information board, were numb and he had to stretch every sinew to snapping point, his feet skittering on the cliff face and sending stones down into the frothing sea below, as he pulled himself up slowly and painfully until he was lying under the board in the sand, panting with the effort.

Luckily, the money, carefully wrapped in a plastic belt around his middle, cushioned him from the sharp stones lining the cliff edge.

He sat like that for a while until he had caught his breath and taken stock. He was miraculously free now, although it had been touch and go for a moment as he hung from the tourist board, his legs floating in the void above the sharp rocks far below. The board had blocked his body from view but if Eric had looked down at that moment and seen his fingers clutching the metal stakes... It didn't bear thinking about. Such a pity about the Maserati but he'd easily be able to buy another one now that he had the cash.

With stabbing pains in his shoulders, Steve finally heaved himself up and stood on the side of the road with his thumb out. Soon, a dusty blue Peugeot stopped for him.

"I was walking in the mountains," explained Steve apologetically as

the driver of the Peugeot eyed his ragged T-shirt and shorts suspiciously, "and now I can't find my way back home. But if you could give me a lift to Villefranche, I'll be able to get my bearings."

The driver said, nodding, "Ah, I see". He leant over and opened the passenger door and soon they were driving off in the opposite direction to that taken by the white van.

Steve gazed out the window at the stunning coastline and the sea that had gobbled up the Maserati but that hadn't gobbled up the money or him. Sea of Joy. And he smiled.

⌘ 21 ⌘

Holiday

"Where are we going on holiday?" whined my little brother Kyle.

"Italy," said Mum.

"Kei Mouth", said Dad at the same time. Dad chuckled and patted Mum on the hand. "Don't worry, old thing. We'll go to Italy next time." It turned out that Dad's brother, Mike, and another chap, Dave, were going deep-sea fishing at Kei Mouth and Dad wanted to go too.

So we hired a caravan and packed all the expensive fishing gear that Dad had bought on purpose for the trip. My brother and I were beside ourselves with excitement about having our first caravan holiday. Kei Mouth was a boring 8-hour drive from Johannesburg. Dad was in his element. "You'll have great fun," he said to my brother and I over his shoulder as we squabbled in the back.

Suddenly, Kyle squealed, "Mum! Dad! I'm going blind! The end of the road is all shimmery! It's melting!" I could hear that he was near to tears.

Dad chuckled. "It's only a mirage, caused by the heat," he explained jovially.

I leant forward between the seats to ask how many more hours we'd have to drive.

"Ow!" shrieked Mum, swiping at her hair. "Sit back! You're pulling my hair!".

I sat back and sulked. Mum lit another cigarette, her elbow out the

window. I held up my sunhat to prevent hot embers from blowing into the back.

Finally, we arrived at the campsite. Our cousins were already there, luckily, because Dad didn't know how to park the caravan, then he couldn't unhitch it from the car. He kept repeating "Hells bells and buckets of blood," through clenched teeth until, after much huffing and puffing, the caravan was suitably parked and connected to the water and waste pipes.

Mum sat in a deck chair with Auntie June, drinking gin & tonic, smoking and giggling behind their hands at the men's efforts.

It was supper time so the picnic tables were unfolded and chairs arranged around them. We kids were fed first - sandwiches in Tupperware containers, crisps and cokes. It went dark very suddenly but it was exciting giggling in the light of paraffin lamps, listening to the chattering of monkeys and strange noises in the veldt.

We were sent off to put on our pyjamas and brush our teeth then, after the requisite time arguing about who would sleep on the inside and who would be closest to the ladder, we finally fell asleep to the sound of the grownups laughing uproariously at their own jokes on the lawn outside.

The next day when we woke up, Dad had left already. "You have to get up really early to go deep-sea fishing," explained Mum. She was still in a relatively good mood and gave us Frosties and milk for breakfast, even though I would rather have had Rice Crispies. Our cousins came out of their caravan and had their breakfast too then our parents told us to push off. "Go and explore. Watch out for sharks. Come back for lunch at one." So we went off in our swimsuits and slipslops and explored.

We gave a wide berth to the long, low administration building and went to check out the playground, which wasn't much but it did have swings, which I liked. My cousin Lily, who was a year older than me, wanted to go to the beach and we were supposed to stay together so I let her go ahead with Kyle and Rosy, the little ones, then caught her up a while later with Robert and Frank who were trying to set the bush alight

with a magnifying glass. Someone rushed out of the administration building and started shouting at them so we all ran towards the beach.

I think we must have been the only people at the campsite. There were just a couple of fishermen sitting on deckchairs with their rods attached to little stands.

"You kids, go and play the other end," they shouted. "You'll scare off the fish."

So we walked a mile or so down the beach in the other direction. There were a few thatched roofs behind the dunes, otherwise nothing but dry grass and endless beach. The surf made such a noise that we had to shout to be heard.

"I'm going in," yelled Lily. "Watch Kyle and Rosy!" She kicked off her slipslops and ran into the surf, shrieking from the cold.

"I'm going in too!" shrieked Kyle. "Me too, me too", shrieked Rosy.

"No, you're not," I shrieked, grabbing their hands and forcing them down onto the sand. "You're going to build a sandcastle. Two castles." I sat next to them to get them started.

Robert and Frank loped up then and said, "Where's Lily?" I pointed. As I did, we all saw a black fin cutting slowly but inexorably across the water.

"SHARK!", we all shrieked with one accord, waving crazily at Lily. Luckily she wasn't far out and was body surfing so she saw us and took the next wave in. The shark just went off down the coast. Perhaps it hadn't even seen her. Perhaps it was a porpoise.

The tide was coming in and washed away the kids' sandcastles. The crying and screaming and whining was unbelievable. Lily and I had to take them by the wrists and drag them along towards the campsite.

We passed a small pool and Kyle wriggled free and jumped in before we realised what was happening. "Wanna swim," he said. We watched agog as he began to sink very slowly. "I'm sinking!" he shouted.

"Oh, God, it's quicksand," said Lily. But we both just stood there in shock. Suddenly, Frank elbowed us aside and was in the pool before we could react. He snatched up Kyle and was out of there like a shot, with Kyle open-mouthed and goggle-eyed under his arm.

"Stupid twit!" I shouted when I had found my voice. "Not you, Frank - Kyle!".

Frank looked disgusted. "Now that I'm all wet, I'll see you all at the pool," and he stalked off with an admiring Robert at his heels.

"Pool?" I said to Lily. She just shrugged. "Didn't know there was one." But just inside the campsite fence, we saw a wooden sign with an arrow saying 'Swimming pool'. It was green with algae and had leaves and insects floating on top but there was a diving board and a couple of rubber tubes lying on the slate surround. We started diving through the tubes to see who could make the smallest splash.

At one point, we noticed Kyle and Rosy bouncing on the end of the diving board so we started to egg them on.

"Go on, do a pike dive," shouted Lily.

"What's a pike dive?" asked Rosy. Then Kyle gave a huge, hard bounce and Rosy went flying off the board and hit the water on her stomach.

"Ow! That hurt!" she spluttered. Kyle dive-bombed too close to her and we had to tell him to stop. Frank and Robert were lying on their stomachs on the edge of the pool at the shallow end, talking in low voices and bursting into goose honks of laughter at some joke or other.

We stayed at the pool for quite a while until Rosy saw a snake. She hopped up and down, pointing at it under a tree and screaming, "A snake! A snake! It's gonna bite me!".

"Well, how would it know you were even there?" said Frank. The air filled with honks and Lily and I doubled up laughing.

"I'm hungry. I want to go back to the caravan," said Kyle.

We discovered we were all hungry so we started back and found the tables laden with watermelon, bread, ham and boiled eggs. After lunch, we were sent to have a rest.

"But we aren't tired," we whined.

"Read your book then," retorted Mum, "but no talking."

We grumbled for a while then slept till four when we heard Dad using the F word just outside the door. Mum came stomping in to get the first aid kit from the bathroom.

After that, things degenerated. We weren't allowed to swim in the

sea because of the sharks (which we should never have told the grownups about), Lily scratched her back on the valve diving through the tube in the pool, Robert punched Frank in the face and the sun seemed to creep over the yard arm for the grownups earlier and earlier.

On the drive home three days earlier than planned, crawling along the endless road with the caravan swaying behind us, Dad chuckled to Mum, "Well, we won't be going on another caravan holiday any time soon!".

"Holiday??" shrieked Mum like a cork popping from a champagne bottle. "You must be bloody well joking. Spending all day sweeping sand out of that caravan, cooking on a primus stove, washing up in a thimble." She sniffed.

"Sleeping in bloody sleeping bags," grumbled Lily.

"Going bloody fishing," spat Dad nodding in agreement.

"Watch your language in front of the children," snapped Mum, lighting up and looking out of the window and the miles and miles of red scrubby desert and purple mountains.

"Look! A mirage!" shouted Kyle, pointing. And that was that.

⌘ 22 ⌘

Fear

I used to sing for my friends, and my uncle, who was a real jazz singer, gave me a guitar for my thirteenth birthday. I'd been writing songs for as long as I could remember, although people sometimes called them poems. I was so lucky I was born with this great voice, strong and silky, and I could do just anything I wanted with it. And all I wanted to do was sing.

I remember when I was older and my uncle asked me if I wanted to join him at the club where he sang regularly with his band, and maybe sing a couple of numbers. I was so excited I had butterflies in my stomach but when he called me onto the stage and all eyes were on me I just froze. I looked out at all those people, and the little club was packed, and I felt their eyes on me like the guns of a firing squad. So I just stood there and I thought my heart had stopped.

Then everyone started clapping and chanting, "Sing! Sing!"

My uncle leaned towards me and whispered, "Just close your eyes and sing for yourself." So I did, and it worked. My voice just slid out of my throat, entwining itself with the instruments then embroidering over my uncle's backing.

I can't tell you how relieved I was when we finished and everyone clapped and yelled. I almost wanted to go on and on forever but I just bowed and went back to my drink.

That was the beginning because there was an important producer in the audience and he came up and wanted to sign me up to give concerts.

I was petrified. "I'll never be able to do it," I told my uncle.

"Of course you will," he said. "Everyone's petrified to start with but then when you get up there and start singing, you'll forget about all those people staring at you and you'll be fine. Trust me!"

So I did. And I have to say, he was right. My trick was to close my eyes, at least in the beginning, then it was just me and the song and my voice, which I played like an instrument and which never let me down.

The real trouble began when I won that award. All of a sudden, I was famous. People phoned to ask me to appear in TV ads just for a few seconds or to sing at concerts and events all over the world. My uncle, who was my agent too, organised my schedule but I started feeling trapped.

"I don't want to do this tour," I said to him.

"But think of the money! You'll be safe for life. You'll never have to worry about anything again."

But I already had enough. I'd bought a flat but I hardly ever had time to live in it.

Then whenever the car came to take me to some concert or other or to the airport to catch some plane or other, there were crowds pushing and shoving, touching me, shouting, screaming in my ears, and I came to dread this. I didn't want to go out anymore but luckily all I had to do was pay someone to go out for me, to do my shopping, for instance. But I became a prisoner in my fancy hotel rooms, a prisoner of all those people who organised my life and lived off my voice like parasites.

"I don't want to do this anymore," I told my uncle. But he wouldn't let me stop. I didn't want any more money but I think *he* did, so he forced me to go on.

"You can't stop now, it would be suicide," he said.

So I ordered whisky and wine from room service to dull the pain. Once, I even refused to sing. I was already on the stage. Or at least that's what they told me. I had drunk quite a lot before going up there and I don't remember very clearly. But I remember thinking that they couldn't force me to sing if I didn't want to. And in fact they had to cancel the concert.

All I wanted was to stay at home and go back to the way I had been as a teenager. I wanted to go shopping with my friends without being

mobbed. I wanted to sing for people I liked, or not sing if I didn't feel like it.

But they wouldn't let me. I had signed contracts. I said I didn't care if I had to pay penalties, if my so-called career was ruined. But my uncle cared and I felt guilty. He said I owed him.

In the end, I couldn't go out without having stoked up on alcohol first. I dreaded leaving my room. Even in the hotel lobbies, people crowded and shoved, pushing microphones and autograph books under my nose. I just couldn't stand it any longer.

Then one day, as I was going through the revolving door into my hotel, I saw all the crush of people in the lobby so I just kept going round. But on the pavement side, there was an even bigger crush of people. It was then that I realised there was no escape and that I would have to stay inside the revolving doors forever, like a monkey in a cage.

But I was wrong. There *was* an escape. The pain came suddenly, like a dagger in my heart, and as I slumped to the floor, my last thought was relief at never having to face those crowds again.

⌘ 23 ⌘

A Walk in the Park

We approached the zebra crossing and Maria leapt off the pavement, wheelchair first, almost tipping me out. I clutched my rug about my knees as we sped across in front of a row of grinning radiators and sinister headlights. Then I was tipped backwards and propelled at a reduced speed across the wide pavement and through the wrought-iron gates of the park.

"I tol' you many times, you need to hol' on when we cross the road or you fin' yourself on your face," chided Maria. I replied in my head, I tol' you to go slower across the roads...

The trouble was, I mused as we crunched along the gravel walk, my son Hugh was paying Maria's wages so it was a delicate matter to criticise or complain.

The park was almost empty this early on a brisk autumn weekday morning: just the usual hobo on the usual bench, a few dog-walkers and a couple of nannies or mothers with children in pushchairs or babies in prams.

As we trundled past the dog garden, Maria slowed down and shouted in my ear, "This is where they bring their dogs now! You see? They don't let them mess up the paths any more."

I nodded obligingly, remembering how I had walked Hector in this park and how he had loved the dog garden but refused to do his business in it, preferring to do it on the path five minutes later, obliging me to stoop and clear up after him. Hector had died at least ten years

ago and I'd never had another dog. To tell the truth, it was a relief not to have to go out in all weathers to take him for his twice-daily walks.

"Oh, look at the cute baby!" gushed Maria next, drawing to a halt next to a pram containing a round-eyed infant. The nanny, another diminutive Philippine lady in a black coat, smiled and nodded at Maria while continuing to talk into a mobile phone.

The child reminded me of my daughter Gina. I used to wheel her through this park too, always worried she would be cold (as I was) so walking briskly under the illusion that I was warming us both up.

"Are you warm enough now, Mrs P?" shouted Maria in my ear again. I'd told her a number of times that I could hear perfectly well but she was obviously trapped in her stereotype of the elderly - deaf, difficult and demented.

So I just nodded and said, "Yes, thanks," in a deliberately low voice. Not that she listened to my answer.

"I know how you feel," she'd informed me more than once.

I remembered, too, bringing Gina to the park on the weekends to roller-skate, her whining cry when she fell and scraped her knee on the gravel. The paths are tarmacked now. And I remembered teaching her to ride a bike. Mike had been alive then and gave her a push then ran behind her, his arms out ready to catch her as the bike wobbled and keeled over.

We had reached the round pond with a fountain in the middle and ducks swimming around or crouching on the banks. A gardener with a wide rake leisurely piled up autumn leaves before forking them into a black plastic bag. The path around the pond was lined with centuries' old chestnut trees, their warm shiny conkers peeping out from spiky crusts.

Maria was shimmying along the gravel path at a certain speed, intent on winding up her morning chore as rapidly as possible. She pretended not to hear me when I asked her to slow down.

"Maria, please," I said more loudly. "Go more slowly - I want to see if there are any mushrooms. It's the season." Maria sighed and slowed down almost imperceptibly as I craned my neck to examine the rich earth under the chestnut trees.

"Well, it's up to you, of course, but if we dawdle here, we won't have time to make it back before the shops close for lunch," she sniffed. "Anyway, you'll catch cold if we go too slowly."

As we briskly returned to the park gates, I started feeling cold and clutched my rug closer about my knees, wishing I could just leap up and run off as I used to do many years ago. I could remember clearly how it felt, how I'd flown down stairs three or four at a time, barely touching the banisters, how it felt to twist and bend, spin and jump. I was lucky I'd been able to do that in my life and, as we waited to cross the main road again, I thought how lucky I would be if I became deaf soon so I wouldn't have to listen to the traffic noise or Maria's patronising remarks.

⌘ 24 ⌘

A Gathering

There was a long queue outside the cake shop so I left my husband in line and went on ahead, stepping carefully in my moon boots over the slippery cobbles in Borgo San Frediano then into Via San Giovanni just as the signature tune of the one o'clock news came blaring out from every window in the street. Dirty snow and slush was piled up at the kerbs and other figures, parents and children clutching cake boxes and bouquets, plodded down the road towards grandparents' houses for Christmas lunch.

I rang the bell then looked up automatically as Paolo, my brother-in-law, leaned out the top floor window to see who it was before buzzing me in. I peeled off my outdoor clothes and moon boots in the never-used sitting room then went through to the always-used dining room next to the kitchen. The table was laden and I saw two extra places. After kissing my parents-in-law and wishing them "Auguri", I said to my father-in-law Benito, who was wondering around pulling up his trousers and getting in the way, "Who else is coming?"

"Uncle Enrico," he replied, hang-dog fashion. "And his fiancée."

Right. Uncle Enrico had never crossed the threshold of my in-law's home in living memory, there having been a falling out after the war for reasons that are another story in themselves. But he was Benito's older brother and Benito was 78 so a fiancée was even more unexpected than Enrico's presence at the Christmas feast.

My mother-in-law Nella beckoned me into the kitchen to help

spread the liver paste on the crostini and arrange ham on a platter. "She's after his money," she hissed, opening the oven and stirring a sauce at the same time.

"I didn't know he had any," I replied.

"He owns that huge old flat in Via Maggio. He owns it, you know. That's worth quite a bit," she informed me. "It would have gone to Massimo and Paolo, but now...".

I mulled this over as I threw the hand-made tortellini into boiling water and stirred them about. Massimo, my husband, had never said anything about Uncle Enrico having any money. He probably didn't know. Or didn't care, which was more like it.

The doorbell rang and Paolo went to buzz in my husband. They conferred in the hall and I presumed that Paolo was bringing Massimo up to speed on the Uncle Enrico question. Then the doorbell rang once again and up came Uncle Enrico, large and friendly and not in the least abashed by the unusual circumstance of his being in my parents-in-law's flat, proudly introducing a little old lady with white hair pulled back in a bun and a huge cameo brooch at her throat. After the flurry of "Auguri's" and cheek-kissing and "Pleased to meet you's", we subsided into our appointed seats and Nella started serving. The television was reluctantly turned down as the Pope waved from his balcony and wished everyone a Merry Christmas.

The bad weather was discussed over the crostini, ham, and tortellini in consommé, nothing was discussed during the tortellini with capon sauce, which was too delicious not to demand our full attention, but when the boiled capon with green sauce and pickles arrived, the subtle interrogation of Lisetta, the fiancée, began.

"So do you have any family, Lisetta?" enquired Nella.

"No, not any more", Lisetta replied. "My family was from Venice, you know. But there's no one left any more. Just me." Enrico leaned over and covered her little hand with his great paw on the tablecloth.

Well, that explained the strange accent that everyone craned towards her to understand.

"And what brings you to Florence?" inquired my father-in-law Benito.

"Oh, she's been living here for many years now," explained Enrico. "She was living in the flat right under mine and we'd never spoken to one another until just recently. I hardly ever go out, you see."

So she had no family of her own. Conversation turned to the weather. Nella and I cleared away the plates and re-set the table for the roast capon, roast pork kidneys and a variety of vegetables. Nella cut rough slices of bread from a huge round that she clasped to her breast, cutting towards her with the sharp knife and always miraculously stopping just short of committing a premature autopsy. The 2-litre flask of Chianti clad in straw circulated.

"So I suppose you'll be moving in with Enrico after the wedding in the spring?" queried Benito kindly, helping himself to a drumstick and smiling encouragingly at Lisetta.

"Yes," she answered. "My flat is much smaller so it would make sense to move into Enrico's". A hand on his arm and an adoring look was bestowed on the future groom.

Ah. "Oh, and do you own your flat yourself or are you renting?" wondered Nella.

"Renting, I'm renting of course," said Lisetta with a little laugh.

We all exchanged meaningful looks over our chomping jaws and laden forks. A gold-digger, obviously: all alone, no family, no means of support. Whereas Uncle Enrico had his war pension and owned his own flat. Which had been earmarked for Massimo and Paolo since Enrico had never married and had no children of his own. What a disaster! How could we decently prevent this jezebel from taking advantage of Uncle Enrico?

It was only when the panettone, nuts and tangerines were on the table and the welcome bubbling of the coffee percolating could be heard from the kitchen that Lisetta continued.

"As I said, I'm renting my little flat in Via Maggio because my villa in Fiesole is being refurbished. I suppose we'll move there when it's ready. Or we could move to the house in Venice but I'm renting that out at the moment. I'd have to give the tenants notice. Of course, it would be entirely up to Enrico." Another adoring look was exchanged between the couple.

Enrico looked around the table and commented, "Whatever my Lisetta prefers is what I'd prefer. I'm entirely in her hands. Specially since I don't own my flat any more. I'm just renting. I had to sell it twenty years ago and now all I have is my pension, while Lisetta... well, Lisetta is well provided for."

After a moment's silence, the bottle of vinsanto was brought out and the biscottini handed round and a toast that seemed quite sincere was warmly proposed to the new member of the family.

⌘ 25 ⌘

Revenge

I had just received the results - dazzling - of my final oncology examinations and had decided to pop the question over a celebratory dinner at La Chaise. I'd already been offered a permanent contract with a leading teaching hospital from September so Laure and I could start looking for a suitable apartment over the summer.

She looked ravishing in her red dress and my heart was pounding as I reached for the ring in my pocket.

"Laure, I'd like to take this opportunity...", I began, clutching the stem of my champagne glass to stop my hand from shaking.

"Stop," she interrupted me. "I know what you're going to say. But I came here tonight to tell you something." She wouldn't meet my eye and I knew, before she said it, that I was being dumped.

My rival turned out to be an estate agent called Jerôme.

In shock, I accepted a posting with Médecins Sans Frontière in Lesotho for the summer, so I could start the healing process on myself and gradually forget about Laure. But she was always at the back of my mind, even when I returned home to a wet autumn and my new job at the hospital.

I threw myself into my work and slowly and painstakingly built up a reputation for myself. On top of my consultations, I read voraciously, attended international conferences and published a series of articles on a new drug that I was developing to cure certain types of cancer. I opened

my own private clinic in a desirable area of the city and was regularly invited for interviews and talk shows.

I never married in the end and, if I ever thought of it, Laure flashed into my mind, Laure and the life we never had, Laure and her miserable estate agent Jérôme, Laure in her red dress.

Then one day I met her again by pure chance. My receptionist knocked and stood aside for my next patient. "Mme Delmare," she announced, and when I looked up, there was Laure.

I froze and she smiled easily as she took my hand. "Hello, Pierre," she said. When I had gathered my wits, I asked her how she was keeping. "Fine, thanks. I have three children now. Jérôme and I married... you remember?"

"The estate agent, yes," I said as airily as I could to cover up the sudden surge of pure hatred that I felt for him. She looked as beautiful as always, and I told her so, although she was somewhat thinner than she ought to have been.

"So what brings you here?" I enquired, although I felt I knew already. She told me her symptoms and I examined her then ordered blood tests and a scan. When the results eventually came through, they confirmed my worst fears - Laure had cervical cancer.

When I told her, she cried and begged me to help her. "I have three children, I'm young, I still have so much to do," she sobbed. "How long do I have?"

And of course that was the crux, the vital question, and also the unanswerable question. There was no cure at the time and the drugs available would only keep her alive a few more months than she would have had otherwise.

The next time she came in for a check-up, the estate agent was with her. He was cordial although obviously extremely worried about her, protective and patient. And when she looked up at him, I suddenly hated her too. She was supposed to look at me like that, not at him.

"Isn't there anything that can be done?" begged Jérôme, his arms around Laure's shoulders as she dabbed at her eyes, grey-faced.

I tried to comfort them, using all the usual clichés, but after they had left, I got to thinking. The drug I was developing was almost ready

and in the first stage of trials. Of course, I couldn't give it to her until the trials were complete and the results had been approved by the drug marketing board and it was too late to include her in the trial. But I had a few samples of the drug locked up in my safe at home.

That evening, as I watched the television unseeingly and sipped automatically at my evening scotch, a plan began to congeal in my mind. My first impulse had been to use the drug on her secretly and hope that it would effect a miraculous remission. But I couldn't stop thinking about what could have been, how happy we might have been together. The three children should have been mine and she should have been sitting beside me on the sofa in her red dress, her head on my shoulder. If only she hadn't been unfaithful to me. If only Jérôme hadn't been in the picture. If only he had been the one to have cancer.

I hated them both then. They had ruined any hope I had of leading a normal life, of happiness, of family holidays, of Christmas with my children.

When they came in the following week, after I had examined Laure, I asked Jérôme how he was feeling. "You really don't look well. Although," I added hurriedly, "it may just be the stress of this situation. But allow me to examine you quickly just to be sure."

Of course, he was fine although a little run down which was to be expected. But I ordered a blood test for him anyway then had the unenviable task of breaking the news to the two of them: Jérôme had cancer too - cancer of the pancreas.

They were completely distraught. Once their sobs had quietened, I played my trump card. I sent Jérôme out into the waiting room and said to Laure, urgently: "I may have a solution, at least for one of you." Her red eyes looked into mine uncomprehendingly. "I'm developing a drug that might cure your cancer. In fact, it almost certainly will. But I'm not allowed to give it to any of my patients yet as it hasn't been approved and the approval process will be a long one. Too long," I said meaningfully, looking straight into her eyes. She buried her face in her hands. "However," I went on, "I have a sample box. Just one. And it would be enough. But you would have to take it in complete secrecy. You wouldn't be able to tell anyone at all."

The hope in her eyes was touching. Then the truth hit her. "But what about Jérôme?"

"I only have one sample. I'm so sorry, Laure, but you'll have to take it. I don't have any for Jérôme." I watched as a thousand conflicting emotions fled across her features. She was shell-shocked, as well she might be. "Don't worry," I said in my best bedside manner. "Jérôme will probably be fine. His cancer is in the earlier stages and can probably be cured with chemo and radiotherapy. You're the one who should take the drug."

But I knew I had sown the seed of a doubt with my 'probably' - he would 'probably be fine'. She knew that 'probably' didn't mean 'definitely'.

The next day I gave her the box of drugs. "Come back and see me next Thursday and we'll see how you are," I said.

She never came back. Neither did Jérôme. So I never knew whether she decided to give the drugs to Jérôme or take them herself. The decision must have been a hard one to make, I thought with satisfaction. In any case, it wouldn't have made any difference since I had substituted the drugs with placebos. She would die anyway and Jérôme, who never had cancer in the first place, would suffer not inconsiderably, what with one thing and another. I began to feel infinitely better, as if a huge weight had been lifted from my heart. Revenge was not only sweet - it was the light at the end of the tunnel.

⌘ 26 ⌘

Liberation

It was after nine and almost dark when Frank roared into the cobbled yard in front of the farmhouse and regretfully cut the engine of his dark blue Harley. Light showed yellow through the kitchen window and the aroma of duck *à l'orange* tickled his nostrils as he pushed open the door. The table was laid as always and he was disappointed to hear Alice humming in the kitchen.

"Oh, hello darling. How was your day?" she trilled, coming through and kissing him on the cheek. Wiping her hands on her apron, she looked up at the clock over the fireplace. "Good Lord, is that the time already?" and she bustled back to the kitchen to fetch the dinner.

Frank flopped into his chair, immensely irritated that Alice did not seem to take issue with his coming home a good two hours after his private lesson with Marie was scheduled to have ended.

Although he had started the affair with Marie casually and without any ulterior motive, automatically making up excuses for Alice and confining the affair to the daylight hours when he could have been doing any number of legitimate things in town, he had now decided that he had fallen in love with Marie, who had just inherited a large house and comfortable income from her defunct mother. He had been living with Alice for over ten years and she was several years his senior. The time had now come for a change in his life. Marie wanted to get married and start a family and Frank thought it might be quite pleasant to have

a child of his own. Alice was too old and uninterested in children and, frankly, she had outlasted her usefulness, Frank thought.

However, how to handle the breakup was sensitive. It was vital that Alice be the one to throw *him* out so that he could leave without having to go through the "If-you-leave-me-I'll-kill-myself" phase. So he decided to change tactics and drop hints about his affair until Alice confronted him, then he could confess all, beg for forgiveness (which he knew perfectly well he would not get) then roar off into the sunset back to Marie, with Alice hating him and wishing him good riddance.

Frank was a private tutor and gave German lessons to various individuals in the town a half hour's drive away. Marie had taken up German after having exhausted a piano teacher and the possibilities of a French cooking course and had asked Frank to move in with her, believing that he was unhappily married. Given her now prosperous circumstances and his feeling that there was no more to be had from his relationship with Alice and her smallholding, which was far too small, he now realised, Frank acquiesced to Marie's insistence and assured her that he would heroically ask his wife for a divorce. Not actually being married to Alice, Frank only wished to extricate himself from this relationship without Alice hounding him to stay and without unnecessary tears and screaming.

But although he had come home unusually late and with a deliberately lame excuse several times in the past few weeks, Alice did not seem to be rising to the bait. "My poor baby, you're working yourself ragged," she would say instead, ruffling his hair sympathetically.

The following Monday he arrived back at the farm at 11 pm, which even for him was provocative to say the least, considering that his last lesson was supposed to finish at 7. He had made sure that his work timetable was displayed on the fridge so that Alice would be sure to notice his lateness. However, when he walked in, she only called from the sitting room, "Your supper's in the oven. Bring it through here - I'm watching 'Special Reporter'. It's really interesting this week."

The same thing happened again and again - no reaction from Alice, even when he did a lipstick-on-collar number, which he understood from a number of films to be sure to attract unfavourable attention.

Marie was becoming increasingly insistent that he make a move. He tried staying with Marie overnight but when he marched defiantly into the farmhouse the following afternoon after his day's lessons, bracing himself for The Scene, he found Alice cutting herbs with scissors just outside the kitchen door. She shaded her eyes from the setting sun and smiled at him. He froze in his tracks. She smiled! The horrible suspicion dawned on him that she had not even noticed his absence. This was confirmed when she said, "You must have got up really early this morning - I didn't hear you leave. Did you have breakfast in town?" Another smile.

Frank was anxious and broke out in a rash. Why wouldn't Alice notice his behaviour? But she stubbornly continued being pleasant to him and ignoring his lateness or even absence without comment. After several months, it became plain that he, Frank, would have to broach the subject after all. He would have to make a clean breast of it and risk Alice's sobs and supplications. The Scene would no doubt last for weeks, with Alice sending him text messages, barging into the school where he taught, screaming at him on the phone... He couldn't bear the thought and procrastinated for another couple of weeks before finally plucking up his courage.

"Alice, we need to talk," he blurted out one evening. Alice lay down her knife and fork, sat back and gave him her full attention.

"What is it, Frank? You look so worried," she breathed, her brow furrowed in commiseration.

He took a deep breath and mumbled, "I'm having an affair."

"Yes, I thought you might be," replied Alice after a pause. "Don't worry, though. I forgive you. It happens to a lot of people after living together for years and years like we have."

This was not the answer he had been hoping for. Frank found himself forced to confess to Alice that he wanted to leave her and move in with his new flame.

"Of course you want to have children, I quite understand," said Alice soothingly. "And I'm too old now, so of course you must go."

She didn't help him pack though and he felt that his departure was, after all, rather an anti-climax. As he roared away into the sunset on

his motorbike, he wondered whether he was doing the right thing and thought back with affection to the tranquil ten years he had spent with Alice. He also, unusually, felt guilty at how he had treated her, poisoning the expected relief he had thought he would feel and the excitement at the prospect of his new life with Marie.

Alice stood at the kitchen door, her hand shading her eyes as she watched him go, listening to the roar of his motorbike gradually fade away until the air was still and clear in the gathering dark. Then she turned back into the kitchen, sat at the table and dialled a number on her mobile phone.

"David? Hi, it's me. He's finally left. Come over now so we can celebrate. Liberation at last! We'll fetch your things tomorrow." As she ended the call, she laughed to herself. "I'm free now, at last. What a relief!" And she had the satisfaction of knowing that Frank had had to sweat for months before gathering up the courage to come clean with her and that he would be paying for his cowardice and infidelity in guilt for many months, if not years, to come. And of course, she, as the injured party, would get to keep the house.

⌘ 27 ⌘

Fire

"Darling, we're having some people over for lunch on Saturday. Could you take charge of the barbecue?" She knew that her husband loved manning the barbecue and he was good at it too. It gave him something to do and his mates always came over and stood with him for a while, chewing the fat.

"Sure, no problem. You do the salads and marinade the meat then, alright?" said Jack, grabbing his briefcase and giving Elizabeth a peck on the cheek before rushing off to the office.

When he had gone, she sat at the kitchen table with another cup of coffee and thought how lucky she was to have such a wonderful husband. He treated her impeccably, praised her cooking, gave her flowers, admired how she looked. She knew she would do anything for him, anything to keep him happy, anything at all. She had already jettisoned a couple of her friends because he didn't like them much and of course she hardly ever invited her parents or her sister, who didn't approve of him. She saw them anyway but went to their houses instead of asking them over.

Elizabeth was looking forward to the barbecue. She had invited Jack's best friend, Roger, with his wife and his widowed mother with her companion. Then there were two of his colleagues and a man who played tennis with him on the weekends with his wife.

She never invited couples with small children as the noise they made bothered him. In fact, she would have loved to have children but Jack

wasn't keen. He also hated pets and swore he would poison the yapping chihuahua that lived next door and that left its little messes on their drive. So of course Elizabeth took care of it. The tearful owner had been round that very morning asking if they had seen the nasty little dog.

Their neighbour on the other side had a parrot that swore at passing children and when Elizabeth saw a pantechnicon pull up in front of the parrot neighbours, she was delighted to be able to share the news with Jack.

"It looks as though the parrot people are moving out," she said. "We won't have to put up with that squawking any longer."

Jack grunted over his newspaper, "Yes, and we won't have to hear that swearing either. Can you imagine what those people must be like to teach their parrot to swear like that?" He shook his head. "Small little minds, nothing better to do..." he muttered. But she knew he was pleased with the news.

The guests all accepted the invitation to the barbecue the following Saturday and Elizabeth started preparing on the Thursday, ordering the meat from the butcher's and buying the wine and soft drinks that would be needed. She took out her favourite cookbooks and set about making marinades, one for the steaks, another for the pork, another for the chicken etc.. She used fresh herbs from her garden and top quality olive oil and knew that the meat would be juicy and delicious. She would make the salads on the morning of the barbecue as they had to be really fresh.

Saturday arrived and Elizabeth was much relieved when she drew back the bedroom curtains and saw that the sun was shining. She left Jack to sleep while she set to work in the kitchen. He had had a hard week and needed to recover. So she lit the barbecue in good time, set out the crockery and cutlery on the table in the garden and prepared the salads. She was wrapping potatoes in foil when Jack eventually came down, showered and shaved and ready to take up his position at the barbecue. "Lovely day," he said with satisfaction. Elizabeth took this as a personal compliment and smiled back at him.

In the garden, Jack placed the potatoes in the embers and started assembling the condiments and dishes of meat. As soon as the first guests

arrived, he started placing the meat on the grill. Elizabeth, smoothly efficient, let the guests in, showed them into the garden, fetched them drinks and handed round snacks, making sure that everyone was comfortable and had a glass in their hand. She left a glass of wine on the barbecue shelf for Jack, kissing him on the cheek before moving off again. Two friends wondered over and stood chatting and laughing with him as he worked.

The barbecue was a great success and everyone wanted to know how she had made her marinades. "Fresh herbs make all the difference," she confided and her guests nodded in agreement. They particularly liked the rabbit with the thyme and mustard marinade.

As dusk approached and the last guests left, Jack slumped in a chair, circling her waist with his arm and complimenting her on the food. "Oh, I didn't do anything," she replied. "You did all the work. You're a genius with the barbecue," but even as she said this, she flushed with pleasure at his compliment.

A few days later, the new people moved in next door. Elizabeth's stomach clenched with apprehension when she saw a young couple wheeling a pram up the drive. She hoped that the baby wouldn't cry, or at least not in the evenings or on the weekends when Jack was at home. The noise would drive him crazy.

Sadly, the baby *did* cry. The noise wasn't very loud but Jack raised his eyebrows over his newspaper and snapped at her to shut the window so the baby's cries couldn't be heard. Of course, she obeyed immediately and made soothing noises at him but she was worried. Perhaps they ought to have another barbecue soon. Apple sauce might be nice, she thought. Home-made, of course.

⌘ 28 ⌘

Control

Here he came. Buzzy knew it would be today. He looked around the showroom as the iron grills were raised electronically with a loud hum followed by a clatter as they reached the top. There were two other autonomous cars on the floor (or rather 'unmanned ground vehicles' as Greg, the head salesman, liked to call them, rather pompously Buzzy thought). The other cars were larger, sleeker and more expensive than Buzzy but, Buzzy knew, they were less intelligent.

Greg was now standing outside on the apron, smoking a cigarette and looking off to his left, towards the overpass. Grey clouds scudded across the sky and it looked like rain. Greg's jacket flapped behind him, his trousers moulded to his scrawny legs in the wind. Buzzy watched the man with heavy glasses and a blue pullover park in the visitor's bay in front of the showroom and casually stroll over. Greg took one last drag then dropped his cigarette regretfully on the ground, hitched up his trousers and extended his hand towards the visitor.

"And what can we do for you today? I bet you've come to see our new unmanned ground vehicles," he said, ushering the blue pullover into the showroom and towards the most expensive of the five cars. Buzzy watched carefully as the man walked around the brilliant red car, examining it from all sides and pretending not to notice the price tag glaring on the front windscreen. At last he moved on to the blue model alongside, only slightly smaller but with a lower price.

Greg kept up an enthusiastic monologue all the while, pointing out

all the salient features of the cars, praising their performance, relatively low consumption, environmental friendliness and insisting on their comparative safety. The man in the glasses slid into the driving seat of the blue model while Greg leant through the door, pointing out the various buttons on the dashboard. "You can always take control yourself at any time - you just press that button there on your left then you have three seconds and the car will be all yours! Just like a conventional car. Fantastic, isn't it?" He beamed and the man nodded appreciatively.

"Oh, no!" Buzzy thought. "He's going to buy the blue one". But the man was now reading the details on the price tag of the blue car.

"It's rather more than I wanted to spend," he said regretfully, and nothing Greg could say about the advantages of paying in instalments, benefiting from free services or having the car delivered to his home seemed to cheer him up. At last, he caught sight of Buzzy, parked by the office. "Now that's more like the price I'm after," he said, stepping across to have a closer look.

Buzzy held his breath. "I knew it!" he exulted. "He'll prefer me!"

And in fact, after examining Buzzy's bright yellow paintwork, chrome bumpers and jazzy headlights, he slipped behind the wheel.

"Of course," Greg said smoothly, "this is a great little car but it doesn't have a lot of the refinements that the other two have," jabbing his thumb in the direction of the blue model and the even larger red one. "But it's perfectly adequate for running about town. Although the boot is smaller, but... Do you have a family, sir? Children?" Greg inquired, ready to suggest the benefits of the bigger models again, but the man shook his head.

"No, it's just me and my wife," he said.

After Greg had taken him for a drive around the block, during which Buzzy was on his best behaviour, they returned to the showroom and the man said, patting Buzzy on the roof, "Yes, this one will do me fine."

Buzzy was delighted. Greg tapped on his calculator. The man signed papers and the keys were finally handed over. The man entered his address into the GPS and as Buzzy drove carefully out of the parking lot all on his own, Greg was already lighting up another cigarette on

the doorstep, cupping his hand around his lighter. The man in the blue sweater patted Buzzy on the steering wheel and said, "Beautiful little car. You and I are going to get along just fine!"

The GPS sent Buzzy out of the industrial zone and along the main road until he reached the turnoff to the village. He was excited to see where they would be going, where the man lived. His home turned out to be a block of flats just on the other side of the village, near the lake. When Buzzy drew up to the kerb, the man stepped out, extremely satisfied.

But Buzzy's wife wasn't. She came rushing out and stared, hands on hips. Then the shrieking began. "I don't want an autonomous car. I'm perfectly capable of driving myself. I'm not as lazy as *some*!" The venom in her voice was shocking. "They cost double an ordinary self-drive car. How *could* you?" And she stomped back into the house and shortly began wailing. The man rushed inside, brows shrivelled in disappointment and frustration.

That afternoon, they went for a spin, sitting together in the back seat while Buzzy, on his best behaviour, took them for a triumphant tour around the village. Passers-by stared and waved and the man waved back but his wife just sat there with her arms folded across her ample chest, staring stony-eyed through the front windscreen.

They returned home and the wife marched inside but the man patted Buzzy on the hood, whispering, "You did really well, it isn't your fault, and I think you're great." Buzzy swore there and then that he would do anything at all for this wonderful, appreciative owner.

So when the wife reluctantly stepped out, coat on and handbag over her arm, clutching a shopping list, Buzzy determined that he would satisfy her to the letter. Sitting in the front passenger seat, she tapped the name of her favourite supermarket into the GPS and settled back to wait for Buzzy to take her there.

He set off steadily, only gathering speed once he was on the main road. He remained a safe distance from the other cars and indicated well before turning off onto the slip road and sliding into the vast car park in front of the supermarket.

"Park as close as you can to the front doors," instructed the wife from the back, as if Buzzy had a chauffeur in the front seat. Yes, Ma'am.

And that's how the first accident occurred in that village with an autonomous car. The wife was killed outright as Buzzy backed, not into the parking space in front of the shop as expected, but into the concrete pillar to the left of the automatic doors, into the electricity box that held all the wires controlling the doors. The wife was electrocuted in fact, not crushed as some thought.

Buzzy's back section was badly damaged but they patched him up in the factory and he was soon back on the floor, now spray-painted red, and both Buzzy and Greg, smoking in the doorway, waited impatiently for their next customer. The man had decided to give up cars for good and now went into town on a bicycle. Buzzy held a grudge. After all, he'd done the man a favour.

⌘ 29 ⌘

Observation

After supper, my sister Jean and I went out to the warm terrace and lay back in the garden chairs to bathe in the starlight and the warm air of nighttime on K18. We'd only been here a couple of years but Dad said we'd got out just in time. In fact, with our enhanced binoculars, we could see Earth quite clearly, and all its patches and pinpoints of bright golden lights. Western Europe glittered like a jewel and you could see where the electricity grid was thickest in America, with both coasts almost solidly lit while there were patches of nothingness in the middle. Africa was the darkest, except the southern-most tip.

Already in the two years we had been here, the lights had become thinner on the ground, as it were. Between the pollution and the growing scarcity of fuel, Earth was becoming harder and harder to live in. When the first food shortages began, Dad said, "That's enough. That's it. We're going," and he put our names on a waiting list for the first shuttle to K18.

"Do you still miss Earth?" I asked Jean, lowering my binoculars and watching her face carefully. She lowered hers too and closed her eyes.

"I still miss it terribly," she replied eventually.

"What do you miss most?" I asked her, knowing the answer already.

"I miss my friends. I miss Alice and Jill. And I even miss the smell of the school canteen and those awful lunches. Can you believe it?" She

laughed and I knew just what she meant. I missed the basketball team, I missed those frosty mornings in winter when you could see your breath. I missed the snow and the squeak and swoosh of skis in the winter.

But skiing had been banned around our village, just the winter before we left, because of the avalanches. Then, in the summer, there were the floods. We had moved to higher land but the groundwater level was rising, which meant that the land wasn't stable any more and construction was becoming difficult with landslides more and more frequent.

Anyway, although we were homesick and missed our old friends and places, we all agreed that the move had been the right thing to do.

"I know the land is rough here and it's much warmer all year round than what we were used to, but we have a nice house and you have a good school. The university should also be completed by the time you leave," our mother told us. She was determined to be optimistic no matter what, and we were grateful to her for keeping our spirits up.

After all, as Dad had said, "There's no going back. The shuttles only bring people out here - they don't take people back."

Dad had been lucky. He was a geologist so we were all immigrants to K18 with preferential status. Dad was allocated a substantial salary by the World Migration Budget and we lived in comparative luxury. Inside the schoolrooms and inside the supermarket, you could believe you were still on Earth but as soon as you came out and saw the desolation all around, you realised there was a long way to go.

So every night we lay on the terrace, Mum and Dad with the ice clinking in their glasses, talking gently about our futures, and Jean and I with our binoculars.

Over the next year, it became very clear that the lights in the world were gradually going out. The patches were becoming sparser and the interiors of the countries we knew, especially France and Spain, were turning black, with the lights like bright necklaces confined to the coasts. The concentration of glitter in South Africa disappeared first, at least as far as we could see, aspirated into the nothingness of the continent. South America was almost completely dark, as was the interior

of the USA although there was still a fairly solid band of light along the east coast and a muffled glow where Los Angeles must have been.

By the time Jean reached the university, I was in my second year, following in my father's footsteps. The settlement we lived in had quadrupled in size, palm trees and Mediterranean pines had been planted and bougainvillea splashed our garden walls with colour. I had a tentative girlfriend, Merry, who sometimes joined us up on the terrace after dinner. She lived just a couple of houses away.

But as our town grew and our planet became a going concern, the lights on earth were being extinguished. By my third year, there were hardly any at all. One night, Jean remarked, "I don't see any lights at all on Earth. Am I going blind?" I put my own binoculars to my eyes and looked and looked, but I couldn't see any lights at all. I passed the binoculars to Merry who looked and looked but - nothing.

I felt as if someone had punched me in the stomach. "Dad!" I screamed. "Mum!" They came running. Then we all looked, taking turns with the binoculars.

Mum turned away first. "Well, that's that," she said in a choking voice and went back inside before we could be sure she was crying.

Up until then, although no shuttles offered rides back to Earth, we all felt that if the worst came to the worst, we could always go back somehow. The government would arrange it eventually. But once the lights had all gone out, we had to face facts. There was no going back. The people left on Earth, the ones who refused to be picked up and transferred to K18 or to the other habitable planets would slowly become extinct. Like the very old, back in nappies and with uncertain steps, shaking handwriting, regressing to an infantile state until death overtook them, the Earth itself was regressing to some sort of pre-human condition until it, too, imploded.

We looked at each other, wordlessly knowing that our memories were only worth the paper they were written on. I found that I was holding Merry's hand hard when Jean grabbed my other hand and we all just lay there, staring at the now solid black outlines of the continents on Earth. After a very long time, we heaved ourselves up and went inside.

Jean had forgotten her binoculars and went back to the terrace a little while later. She had one last look through them and thought she saw a tiny, an infinitesimal cluster of lights somewhere in France, perhaps around where Paris would be, but she couldn't be sure and went back inside, closing the sliding doors carefully behind her.

⌘ 30 ⌘

It's Midnight Now...

It's midnight now. The house is dark. I don't know how this will turn out.

Earlier in the evening, the Swiss girl whose name I've forgotten, asked me if I'd like to go out with her and some friends. I was ecstatic. I hadn't been out on my own in Prague since my arrival four days ago and wouldn't have dared to go out on my own at night. Also, most of the others in the pension, students at the university, only spoke Czech and I didn't so I was beginning to feel rather lonely.

Outside in the street, I met Tomasz, the Swiss girl's boyfriend, and another girl called Tereza. She had a boyfriend too then there was another boy, very good-looking, called Martin, who fell into step beside me as we walked along the embankment. The city lights twinkled and I was content listening to the chatter of the others. Martin spoke some English and told me he was a student at Charles University. I asked him what he was studying and he said accountancy. Even when we went to a discothèque and in spite of his good looks, I couldn't help thinking, "Boring..." and turned my head away when he tried to kiss me.

Then we all piled into a Fiat 600 and drove to a house near Pirodni Park that belonged to Martin's parents. He said they would go there in the summer to escape the stifling heat of the city but they were on a cruise right now so we could go there without fear.

The house was very old and had a vast kitchen with a marble table in the middle. The others made conversation with me in halting English or

with the Swiss girl as my interpreter. I explained that my parents wanted me to discover my 'roots' - my grandfather was Czech - but quite frankly I would rather have gone to Paris. I didn't say this though, and in any case I had seen that there were plenty of things to admire in Prague.

As we ate Kulayda potato soup made by one of the boys, I tried to join in the conversation. "Yes, it's my first visit to Prague. Then in the autumn, I'll be going to university. I have a scholarship to study archaeology." I was smug.

We drank Moravian wine and it must have been stronger than I thought because when I got up to go to the bathroom, I found that I was a little light-headed.

We listened to music then and I found I was enjoying myself, sitting on the floor and talking to Martin. At a certain point, the others were saying goodbye one by one. I struggled to my feet and realised, rather late, that everyone had gone home and I was left with Martin.

"I think I ought to be going too," I said firmly, casting around for my handbag.

"I'm afraid you can't go until tomorrow morning," he said. "The others have taken the car."

Uh-oh. This was exactly the sort of situation my mother had warned me against and why she always made sure I had 'taxi money' when I went out.

"Martin, could you call me a taxi please? The pension closes at midnight. I really have to be back before then," I pleaded.

He looked at his watch. "Well, it's too late now anyway. You'll never get back by midnight."

I flounced into the kitchen and started washing the dishes and when I shrugged his hands off my shoulders, he didn't insist.

I sat at the kitchen table and lit a cigarette. He lit a cigarette and covered my hand in his own. I felt his hand tremble just before I snatched mine away.

He sighed then said after a minute, "Don't worry. You can sleep in the guest room and we'll get a taxi to town in the morning."

So I brushed my teeth with my finger and slipped between his mother's floral sheets in my bra and pants. I must have dropped off but

I woke up with a snap in the middle of the night and listened like a wild animal. There was a creaking in the corridor and a light showed under my door. Had I locked the door? Did the door lock? Was there any danger? Any chance I might be raped?

The floorboards creaked again, then, frozen, I saw the shadows of feet under the door. The shadows stopped in front of my door. I listened. He listened. Many minutes went by before the shadow slid away, the creaks grew fainter then the light in the corridor snapped off and a door closed. Silence.

I couldn't sleep then so leant on the windowsill looking out over the garden and black fruit trees into the forest beyond, blanketed with a thick black holey sky lit with stars from behind. I thought of Martin's gentle eyes and manly moustache. I thought of my mother, saying, 'I never let a man touch me until I had this ring on my finger' and wondering which of her two rings she meant. I thought of the brain surgeon I hoped to marry one day and of the accountant in embryo down the hall. I thought of the mystery of Prague, of the rightness of returning to my roots. Then I thought of the wrongness of being so far from my friends in Philadelphia, from blueberry pancakes for breakfast and even from mother and her rings.

Then I heard a door squeaking, the light snapping on in a yellow line under my door and steps creaking down the passage again. They stopped and the shadow of two feet hovered. I thought I saw the door handle turn but it may just have been my imagination.

It's midnight now. The house is dark. I don't know how this will turn out.

⌘ 31 ⌘

The King and the Cow

In the shade of the spreading thorn trees, the men from the village and those who had come by bike from the neighbouring villages crouched on their hand-carved wooden stools in a rough circle around the King's high throne and its artfully arranged leopard skin. In the distance some women in their bright cotton could be seen moving slowly around a dozen or so round thatched huts, going about their business with their babies tied on their backs. And beyond the village, on a little rise, stood a much larger and more impressive hut, which was the King's palace.

The gathering glanced towards it from time to time, awaiting the emergence of the royal figure and his entourage of sons, grandsons and hangers-on. Odikinyi (or One Who Was Born in the Early Morning) muttered to his neighbour, Obuya (or One Who Was Born When the Garden Was Overgrown), "Let's hope that our great King can come up with something to help our people this time. With nearly all our cattle lost in the great drought, we are poor." He sighed and stretched out his bony feet in their plastic flipflops.

Obuya, chewing on a stem of dried grass, glanced briefly at his Casio then up at the King's palace. "Here he comes," he remarked. The King could be seen mincing down the red dirt path, followed by his entourage. "Let's hope he has something to propose this time."

The men sat up straighter as the King shuffled into view, his Elvis Presley mirror glasses glinting in the sunlight. His chief wife, the Queen,

as wide as she was tall, lumbered after him and stood at his shoulder as he sank onto the leopard-skin throne. After a certain amount of shuffling and checking to make sure everyone was present, the meeting was declared open.

"I know things have been hard," started the King, "but you need not despair. I am not your King for nothing!" Heh, heh, heh resounded around the circle and the men exchanged knowing glances. "Our King will save us," they chanted ritually and possibly threateningly.

"Now," said the monarch, holding up a hand for silence, "our village will become rich."

"Hail to the King!" shouted many. "And about time too," said a few, *sotto voce*.

The King gestured to his ancient prime minister to explain.

"We are going to have a raffle." Silence and blank stares greeted this announcement.

"Tell them, tell them," instructed the King with a wave of his hand.

The venerable minister resumed. "Every man will buy one or more tickets." He held up a clutch of grubby pieces of paper, each with a number written on it painstakingly in blue biro.

"How much? How much do we have to pay?" called a man.

"Very cheap, very cheap," the King assured them.

"Only one shilling for one ticket", announced the minister. "Only one shilling. And for only one shilling, you get one big chance to win the big prize!" he finished triumphantly, looking to the King for approval. The King nodded; the Queen nodded; the entourage nodded.

The men sitting in the circle looked at each other. One called out: "And what is this big prize?"

"Yes, what is the big prize?" clamoured others.

"This big prize..." said the minister in his quavery voice, "the big prize is..... a big fat cow!"

A great cheer went up from the crowd. "A cow! A big fat cow!" they cried.

"Yes, a big fat cow from the royal compound," confirmed the minister.

"Praise to the King!" shouted the men.

Hands went into goatskin purses and several men could be seen trotting up towards the village, confabulating with their wives, and returning with a few shillings. A hundred tickets had been prepared and the men, although far fewer than a hundred, were urged to buy up as many tickets as they could.

"What if you only buy ninety-nine tickets and the winning ticket is number one hundred?" insinuated the Queen, who stood with a tin box accepting shillings while the minister handed out tickets.

In no time at all, the tickets were all sold. The meeting was adjourned until the evening when the winner would be announced and the men wondered off in twos and threes, examining their tickets and dreaming of owning a big fat cow.

The King shuffled back to his compound and, in the privacy of his hut, rounded on the Queen. "Now what?" he hissed. "All those people have paid their shillings and the bloody cow is dead! They'll kill me when they find out." He paced back and forth, hurling his ceremonial spear into a corner and deerskin cape onto a chair.

"Calm down, now," said the Queen. "You must trust me. No one will know. And look here!" she shook the tin box that rattled satisfyingly. "We are rich!"

That evening, the royal couple returned to the clearing as arranged. The crowd surrounding them was great, the men expectant, each hoping to win the big fat cow. In the most complete silence, the minister shook a leather sack vigorously, plunged his arm into it up to the elbow, then picked out a number.

"The winner is.... number fifty-four!" he cried, holding up the chosen ticket.

Amidst cries of disappointment from the many, a scrawny teenager rose to his feet waving a ticket. "It's me, it's me! I'm the winner! Where's my cow? Take me to my cow!" he shouted.

The minister examined his ticket and, having confirmed that it was indeed number fifty-four, turned to the King who congratulated the young man with a handshake. "Come with us now and we will take you to your big fat cow." The young man set off with the King and his entourage in the direction of the King's compound, hardly believing

in his luck. The other men wondered off disconsolately towards their huts, some grumbling at having lost their precious shillings but most just accepting their fate with a shrug.

When the winner arrived at the palace, the Queen took charge of him. "Now I'll take you to your cow," she said. They went off to the enclosure behind the palace and into a large wooden shed. The Queen yanked the door open and inside, the big fat cow could be seen lying on its side, its eyes glazed. And it wasn't quite as fat as the winner had imagined. Its bony ribs were motionless.

The winner stood transfixed. Then he approached the cow and gave it a kick in its side. There was no reaction. He turned to the Queen, and the King standing behind her. "The cow is dead!" he shouted, his fists clenched in fury. "You cheated me!"

"Oh, dear," said the Queen, patting his arm soothingly. "What a tragedy. Your cow is dead. What a pity. But", and she guided him outside into the compound, "don't you worry. We would never cheat you. Yes, we will give you your money back," she announced triumphantly. "And we will even give you an extra shilling for your disappointment." And she opened the tin box under her arm and picked out two shiny shillings.

The young man was finally mollified. The cow was dead and couldn't be brought back to life but he had won a shilling after all. He went back to the village and told the clamouring villagers what had happened. That night, a big public barbecue was organised under the thorn trees and everyone agreed that the cow meat was delicious.

Then the King announced that he had bought a herd of goats (for 10 shillings) for the villagers to share and in time this herd would grow and grow until everyone was rich again.

"Our King is great!" yelled the company jubilantly. Everyone was happy, including the King as he sat on his throne, the Queen, smiling serenely, stood at his shoulder, as was the custom, clutching the almost full tin box.

⌘ 32 ⌘

A Great New Year

Pasquale slept under the Ponte Santa Trinità and kept his belongings in a dozen plastic bags under a small blue tarpaulin. When he went off begging, he had to rely on the other three hobos that shared his spot with him not to pilfer his stuff while he was away. But it was true that there was honour amongst hobos as well as amongst thieves.

As the mango-coloured sun rose over the Arno, Pasquale would stretch, reach over the slippery bank carefully and rinse his face, then climb up to road level. He made his way cautiously up to the Piazza with its Colonna della Giustizia and rested for a moment on the ledge below the statue, placing his tin cup next to him, tapping it on the stone from time to time as tourists wondered up to take photos. They didn't come too close to him, though, because he stank, but he didn't mind. But the few who did tended to drop a coin or two into his tin cup. The clink sometimes attracted glances from other tourists who might be tempted to follow suit.

As the sun climbed in the sky and the tourists hugged the walls to profit from the shade, Pasquale, too, moved into the blessed cool cast by the towering Renaissance palaces and ambled slowly in the direction of Via degli Strozzi, rattling his cup discreetly when tourists drew near.

He had to be careful though. His daytime activity was not without its mild dangers, even here in the open, on the street. Although the local police knew him and nodded as he shuffled along, ghostly as a wraith,

past the shiny windows of Ferragamo, Valentino and the other luxury stores, the mounted Carabinieri who strutted arrogantly along the embankment or down Via de' Tornabuoni on their high horses would sometimes gesture at him to move on, growling "Move on, move on," forcing him to head down a side street with a one-way system that they couldn't follow him down.

It was so unbearably hot in the summer that he thought he would bake or die from lack of air, while in winter he froze. Yet, he had to spend his whole day wondering up and down the street. It was his street, his spot, and it wasn't bad. Due to the luxury fashion stores, there were always plenty of tourists and he managed to eke out enough to treat himself to a heavily discounted tripe sandwich from the itinerant stallholder around the corner in Via degli Strozzi. And when he did, it was his excuse to keep his eye on Carmelo.

Carmelo had a long beard, dressed in rags and frightened tourists by swearing at them loudly as they passed, quickening their steps, his guffaws following them as they vanished in the direction of Piazza della Repubblica. But he only did this sometimes, to alleviate his boredom, and the rest of the time there were frequent clinks as tourists and locals alike dropped coins into his tin cup, the locals accompanying their offering with a "Ciao, Carmelo", because everyone knew Carmelo. He was as much of a fixture as the Strozzi Palace itself.

Carmelo had the most sought-after begging position in the whole city. Running around Palazzo Strozzi, built over 500 years ago for the powerful Strozzi family, there is a wide stone ledge with a commanding view of the Piazza. Tourist footfall is heavy. And the ledge is comfortable. Carmelo lies there all day, propped on his pile of plastic bags containing all his worldly belongings. At night, he sleeps there. Local bars and restaurants offer him his morning coffee and bowls of pasta or leftovers. From time to time, he buys himself a fresh wheel of farm bread, a chunk of pecorino cheese, a slice of salty Tuscan ham and a 2-litre straw-covered flask of Chianti. He relieves himself in an alley. If he has to venture further afield, the owner of the local bar or the tripe stand keeps an eye on his bags but he doesn't like to stay away for too long in case the other hobos band together and pinch his place.

This was the place coveted by the four hobos who slept under the bridge, but mostly by Pasquale. For years, he had watched Carmelo, spying on him, hoping that one day he would pack up his belongings and shuffle off to some other Piazza or neighbourhood. But year after year, Carmelo stuck to his place on the ledge. Pasquale had no choice but to continue to watch and spy.

In the evenings, once he had milked as much as he could from people going out to dinner, Pasquale returned, shuffling a little faster, to his home under the bridge. The other three tended to look up to him since he had been there the longest and had fought in the war. In the summer, they would curl up beside their belongings, pull out whatever food they had and wash it down with gulps of cheap red wine. Then they would sleep. But in the winter, they would light a fire in an old oil drum and cluster around it for warmth. It could get bitterly cold in winter and snowed from time to time.

As Pasquale turned the corner into Via degli Strozzi and aimed for the tripe stand to collect his daily sandwich, he studiously avoided looking at Carmelo, lying like a Roman emperor on his bags. But he would glance at him surreptitiously as he left, continuing towards Piazza della Repubblica where one of the bars always offered him a 'miscela' of red wine and where he could rest on the marble pavement in the shade under the loggia. In the evening, he would walk back the same way. Although it would have been cooler to take the cobbled side streets plunged in shadow, it was awkward avoiding traffic and other pedestrians on the narrow uneven Vespa-clogged pavements. So he stuck to the wider thoroughfares and squares, once again passing Carmelo on his way back, envying him his ease and comfort, while Carmelo looked straight at him, a small smile in his beard, fully conscious of his superiority.

The summer lasted forever before the darkness started encroaching earlier and earlier, the wrought-iron streetlights hung on the walls of the palazzos shedding their bright yellow light on the hurrying passers-by with their boots and bags, furs and hats, glistening umbrellas and gay laughs. Pasquale slept late before dragging himself reluctantly to the Via de' Tornabuoni to start his rounds. He shivered in his rags, even

though he wore an extra layer, and he could feel the cold stone pavements through the thin soles of his boots. He couldn't wait to return to his lair under the bridge in the evenings and light their brazier, standing shoulder to shoulder with his three fellow hobos. It got dark earlier so he ended up eating his evening meal earlier and settling down to sleep earlier. He was asleep by 7 sometimes, but was plagued by bad dreams in which he died in his sleep under the bridge and wasn't found for days, frozen solid.

Christmas was approaching and the hurrying crowds became more generous, perhaps feeling sorry for Pasquale in his rags. He also didn't smell so bad in winter so people tended to come closer and see the pleading gentleness in his eyes, then he would hear the clink of coins, without looking down, just bowing his thanks. He contracted a hacking cough, which he couldn't seem to get rid of. And his legs hurt so badly. As he shuffled into Via degli Strozzi, he was conscious of Carmelo lying there on his comfortable ledge, looking at him ironically.

After Christmas, it snowed and, what with the freezing, sleeting weather and treacherous pavements, Pasquale found himself huddling next to the brazier under the bridge for several days, without venturing out. He knew it was stupid since it was a time when people were most generous but he just couldn't bring himself to do it. He had a fever and trembled like a leaf and downed more than he should from the Chianti flask, just to warm himself up.

Then, on New Year's Eve, he decided to venture out, if nothing else just to see the people all dressed up on their way to fancy restaurants or private parties. Pasquale wondered if he would ever see another New Year's Eve, but he held out his cup gamely and the coins clinked into it. He couldn't even go into a café to warm up - his clothes were too ragged and he was too dirty. He'd be chased out.

As he approached Via degli Strozzi, he had a premonition that something really good was going to happen to him. He saw an ambulance pass and scratched his testicles briefly as was the custom, to stave away bad luck. He stopped for a moment on the corner, dithering and thinking that he might as well turn back. It had started to snow again and he

just couldn't face going all the way up to Piazza della Repubblica. But something, a premonition, kept him going and he rounded the corner.

And there he saw the anonymous Misericordia volunteers, with their long black robes and tall pointed black hats covering their faces, only leaving eye holes, loading Carmelo, who was frozen as stiff as a board, onto a stretcher and into the ambulance, his belongings thrown in after him. As the ambulance drove away, sirens blaring, Pasquale looked at the now vacant ledge, looked at the people hurrying backwards and forwards, at the bright lights of the bars and restaurants and hesitantly, ever so slowly, pulled himself up and lay down on the freezing stone. He placed his cup next to him and sighed in relief. Finally, after years of waiting and hoping, he had won this exceptional spot.

But you weren't allowed to have a brazier there and, already with a hacking cough, Pasquale soon succumbed, as Carmelo had before him, to the bitter rigours of winter. But that New Year's Eve, when he saw poor Carmelo being borne off by the black caped volunteers in the Misericordia ambulance, Pasquale couldn't help thinking, "This is going to be a great New Year!". And it was, for as long as it lasted.

⌘ 33 ⌘

After the Party

Didier crouched over his chopping board in the kitchen, wiping his hands on his butcher's apron, mopping his forehead from time to time, his brow furrowed in anxiety and concentration, his eyes flicking from the board to the oven, from the clock to the hall door. Jean-François had invited some work colleagues and his boss for dinner and Didier was petrified that his cooking would be a flop and Jean-François would be humiliated.

Didier had spent many sleepless nights mulling over the menu and had settled on wild mushroom soup followed by partridge stuffed with foie gras and with slivers of white truffle under the skin, roast potatoes and a tian of vegetables, followed by a lemon pavlova with red berries. The meringue for the pavlova was cooling on the counter, the cream and berries were already prepared in the fridge and Didier had just slipped the partridges, potatoes and tian into the oven when he heard the key in the lock.

Jean-François let himself in, called "Hi" and hung his coat on the hook by the door, dumping his briefcase on the hall chair. He stuck his head briefly round the door of the kitchen. "Everything OK?" he asked.

Didier nodded. "Oh, I hope so. I think so. I'm so worried..."

But Jean-François just said, "No need to worry. It'll all be fine," adding, "I'll just nip upstairs for a quick shower and change." With that, he disappeared.

Didier popped into the sitting-cum-dining room and checked his

arrangements. A large gilt-framed mirror overhanging the mantelpiece reflected the comfortable yellow sofa, the 1950s armchairs, the glass coffee table with its Japanese dishes of hors d'oeuvres. Their Kilims looked bright and homely. On the other side of the room, the dining table had been set next to the tall French windows opening onto a small balcony. The damask was spotless. The silver they had inherited from Jean-François's mother (before her death) glowed while the crystal glasses they had bought in Venice on their honeymoon, and which they had been so afraid would be broken in transit, sparkled in the lamplight with all their sumptuous splendour. He pressed a button on the Bang & Olufsen and soft jazz seeped into the room.

The Bordeaux was 'breathing' on the sideboard and a bottle of Ruinart stood in an ice bucket on the side.

As Jean-François emerged from their room, with his fragrant cologne and dressed elegantly in grey trousers, brown Velasca loafers and the blue V-neck Pringle sweater that matched his eyes, Didier shot into the bathroom to shower, calling, "They'll be here any minute now. Answer the door, won't you?"

Five minutes later, the doorbell rang and there was Claude, a colleague of Jean-François's at the bank where he had recently transferred, accepting a handsome promotion at the same time, and his wife Marie-Hélène.

"Lovely to see you," said Jean-François, kissing them both on both cheeks as was the custom.

Right behind them hovered his boss, Monsieur Valmont, and his wife Clothilde. Jean-François relieved them of their overcoats and scarves and ushered them into the sitting room. They looked about for slippers, wondering if this was a house where you took your shoes off in the hall, but Jean-François put them at their ease. "Don't worry, the floors are clean!" In fact, the honey-coloured parquet that ran throughout the flat was polished to a high shine.

"Oh, what a lovely place you have!" enthused Marie-Hélène, revealing that she was an interior decorator.

"We only bought the flat last autumn, a year ago," confided

Jean-François. "It was just after the slump, so we bought it at a bargain price."

The doorbell rang again and it was Evelyne, the forty-something divorcée from the top floor. She never seemed to go out (except to the office where she worked as an accountant in some local firm) or have visitors, so the boys thought she might like to join them. She was rather overdressed and wore too much make-up but was welcomed politely by the others.

Once the introductions had been made, Jean-François popped open the champagne and handed round the flutes and canapés. Conversation was genteel but warmed up with the champagne, everyone having something to say about the latest strikes and, of course, the bad weather although it was generally agreed that it was a good thing it hadn't rained this evening.

Then Evelyne, sitting on the sofa, asked Jean-François "You don't mind if I smoke?", pulling a royal blue box of Gitanes from her handbag. There was a second's silence and the other guests unanimously looked disapproving but Jean-François said, "Of course not, but I must ask you to smoke on the balcony, if you wouldn't mind." In fact, he couldn't stand the smell of cigarette smoke clinging to the curtains and rugs.

So Evelyne stood on the narrow balcony, gazing down at the street below, the blue buses and rushing traffic, the ambulance and police sirens, the queues outside the baker's shop and cinema, people hurrying home from work. Over the road, she could see other people, families and couples, sitting at tables having dinner or watching television in the yellow-lighted windows of the flats across the road, and in the distance, the Sacré Coeur and Montmartre. "You have a spectacular view here," she said to Jean-François who had courteously lingered to light her cigarette.

"What a delicious aroma," remarked Clothilde loitering at the door to the kitchen, perhaps envying the top-of-the-range equipment that Didier had insisted on. "I hope you haven't spent the whole day slaving over a hot stove!" she continued to Jean-François, who had rejoined them.

"No, I'm lucky. My partner Didier is an excellent cook and takes

care of all of that side of things. After all, you don't leave me much time, Monsieur," he said, smiling at his boss.

"Oh, we're among friends here. No need to be so formal. Call me Pascal," said his boss jovially, on his second flute of champagne.

Jean-François handed round the canapés again and noticed that no one was eating the foie gras. "We bought this from a farmer in the South West," he said. "Do try it".

"I'm afraid I'm a vegetarian", said Clothilde. "But I'll have a cheese stick," and she helped herself.

At that moment, Didier came in shyly. Shorter and stockier than Jean-François, he looked smart in his crisp shirt and carefully combed hair, still wet from the shower. He was introduced to everyone then a glass was placed in his hand and they drank a few toasts.

Didier, excusing himself, escaped to the kitchen, muttering to Jean-François, "I'll leave it to you to get everyone sitting down. Five minutes and I'll be in with the soup."

Jean-François was loath to tell Didier about Clothilde. Poor Didier had been to so much trouble with his partridges. But there was no way of avoiding it.

Didier just sighed at the news and said, "Never mind, there's the vegetable tian and potatoes, and the mushroom soup so she won't go hungry."

When he came back with the soup, fragrant and rich, topped with cream, chives and a sprinkling of black pepper, he placed a steaming bowl before each guest. But when he came to Evelyne, she said, "Not for me, thanks, Didier. I'm afraid I can't eat mushrooms. They don't agree with me."

Of course, Didier said, "Don't worry, my dear, I'll bring you a little salad." He scurried back into the kitchen, yanked open the fridge and quickly tossed a green salad in some vinaigrette made with his best olive oil.

The guests had all finished the soup and were discussing an imminent takeover of a certain bank by another when Didier unobtrusively removed the soup bowls to the kitchen, nodding at Jean-François to get ready to serve the Bordeaux that they had chosen for the main course.

The plates looked like works of art, with their wine-dark roasted partridge portions, crispy golden roast potatoes fragrant with rosemary, and the multi-coloured vegetable tian on the side. Didier was proud when he took them through and placed a plate before each guest, making sure that Clothilde, the boss's vegetarian wife, received a bigger portion of vegetables to replace her partridge.

But it turned out that Marie-Hélène was also vegetarian and politely asked Didier if he could remove the partridge from her plate, which he did, replacing it with more tian and potatoes.

Just as he had sat down and shaken out his napkin on his lap, Claude said, "I wonder if I could have some sparkling water? Perhaps some Badoit if you have it? I'm afraid I can't drink red wine".

Jean-François jumped up this time and fetched the water.

Didier noticed that Evelyne hadn't touched her tian. He didn't say anything but she saw him looking and whispered, "I don't eat onions or garlic, I'm afraid, so I can't eat this. But I'm sure it's very nice," she added, smiling reassuringly. Didier jumped up and fetched her another portion of partridge to make up for it and she seemed pleased.

Then Marie-Hélène and Clothilde started talking about diets they had been on or were going to go on.

"Neither of you need to go on a diet," said Jean-François gallantly.

"Yes, but it's for moral reasons too," explained Clothilde. "I mean, it's pretty disgraceful the way we all stuff ourselves with food when there are people in the world who don't have enough," and she gestured vaguely around the table.

Didier exchanged a fleeting glance with Jean-François, heavy with meaning. They went on eating and Jean-François' boss, Pascal, did full justice to the food, smiling warmly at Didier and congratulating him heartily. "Best meal I've had for ages," he said.

But his wife leant over and murmured "You'll pay for it in heartburn. Don't blame me."

Damn cheek, though Didier, but what could he say? So he just slipped off into the kitchen and prepared the dessert. It looked magnificent, covered in shiny cream and wild berries, the golden meringue cooked just right, chewy in the middle and crisp on the outside.

He took the plate in proudly while Jean-François handed out the cut-glass dessert dishes. Everyone Ooh-ed and Aah-ed and made complimentary remarks but when Didier handed round the dishes, both Evelyne and Marie-Hélène refused, Evelyne saying, "I'm afraid I can't eat sugar. It's habit-forming, you know," and Marie-Hélène said something about calories.

Didier wondered fleetingly how Evelyne justified her smoking habit.

Then Claude turned out to be allergic to wild berries so Jean-François offered him a Roullet instead. Once the bottle was on the table, Pascal helped himself too and everyone seemed to be having a most enjoyable time.

It wasn't until well after midnight that the guests dispersed and Didier cleaned up the kitchen, putting the leftovers in plastic containers in the fridge, while Jean-François cleared the sitting room and dining room. At last their job was finished, and they sat down wearily at the clean kitchen table, with a glass of the excellent Roullet and a dish of Pavlova in front of each of them.

"You know, you did a marvellous job," said Jean-François, holding up his glass in tribute to Didier. "The food was all excellent. I've never had such delicate, delicious mushroom soup. And the partridge! A *chef d'oeuvre*".

Didier flushed with pleasure. "I'm so relieved", he said. "I so wanted your boss to be impressed."

"And he was, that's for sure!" said Jean-François. "My next promotion will be thanks to you."

"But, you know," Didier confided, "I don't enjoy cooking any more. All these fads and 'I don't eat this', or 'I don't eat that'. It takes the pleasure away. And I went to all that trouble."

"I know," agreed Jean-François. "Whatever happened to the days when people would all just tuck in and be glad they had been offered a great meal? When everyone ate everything?".

"You know what?" said Didier after a while. "I don't think I want to cook for other people any more. Just for you. At least you appreciate what I make."

"I know, I know how you feel. I sympathise, I really do," replied

Jean-François. "I think what we should do is this. Every month we'll have a special dinner party just for the two of us. We won't invite anyone else. And we'll have the best of everything. What do you think of that?"

Didier thought for a moment. "That's a fantastic idea," he said. "I already have an idea for our next one. Write the date in your diary so you won't forget!"

And the two friends and lovers finished their Pavlova in companionable silence, drained their glasses and went off to bed, hand in hand.

⌘ 34 ⌘

Swan Song

My little great granddaughter's hand clutched mine as we rose suddenly, all eyes focused on the Royal Box and the distant personage who appeared therein. The National Anthem crashed to its final notes, the conductor bowed to the Box then waited as the audience shuffled and squeaked to its seats. When you could cut the silence with a knife, he raised his baton and the eerie notes of the overture snaked through the air.

I had slipped coins into the slot and Lily and I raised our opera glasses as the heavy velvet curtain went up to reveal a birthday party of majestic sumptuousness, the costumes of the guests brushstrokes of colour, the backdrop sewn to reflect the tall pillars and elegant marble of a palace. A prince and his doting mother greeted possible brides ebbing and flowing in ever more beautiful gowns, ever more complicated headdresses. The fleeting vision of an ideal is shown to the prince, who obediently spurns all others, and yearns.

Then, in stark contrast, the second act with the curtain rising on a dour scene of lonely treeless hills with the glint of a lake in the foreground.

As the hunting party arrived, I could feel in my own legs the stretching of ligaments to their limit, the tense tendons of the dancers, striving for that perfection, unattainable except to the observer. They leapt and cavorted, grace personified, in their bright, carefully coordinated

costumes, reaching outwards with their bows and upwards with their arrows, twisting every which way that the serpent music led them.

Then, with a crash of cymbals, the quivering white swan arrived, a swatch of purity against the rainy backdrop of a Northern lake surrounded by heath, a foreboding of death.

I glanced down at Lily. Her eyes were shining, her mouth ajar as she watched the shivering, trembling bird move, as if on a breath of wind, across the stage, Lily's muscles straining to move with her.

Then the corps de ballet arrived, smoothly synchronised, sliding across the stage in unison, white arms crossed, the wooden toes of their point shoes tapping on the boards under the music.

The magic of this enchanted story of idealism and broken faith, of idealism and error, of enchantment, destiny and human frailty, unfurled before us, the spell still with us as we shuffled down the aisle in the intermission and stood in a queue for the lavatory.

As we watched the last act disclose the shuddering dénouement, the hideous, inescapable inevitability of death and damnation, I could see that Lily still hoped, still couldn't believe that the black swan would win over the white one, that the poor hunter would not end up victorious to the relief of all.

I thought of my dear husband, Lily's great-grandfather, who had died in the War to end all wars, and our son who had died in Vietnam so long ago, but only after leaving a son of his own, Lily's father. I took her hand and squeezed it far too hard as the pain in the dancers' legs, their bloodied toes, their exhausted limbs, transferred itself to my muscles and the pain of their story dissolved in the pain of my own until I succumbed to my past and my future and the present was just a garish backdrop rising on... what?

What will I see behind it when it finally peels upwards, carrying Siegfried's castle with it, Odile's silvery landscape vanishing into the shadowy heights? A tangle of ropes and ladders, beams and spotlights and dust. Or perhaps my lost men, the ultimate in artistic expression, the work of art that tries to improve on reality and actually succeeds.

⌘

And that was the last Lily saw of her Great-Gran. But she'd always remember her scent, her white dress, her white hair pulled back like that of the dancers and the smile on her face as she slumped there, her opera glasses forgotten on her lap and Lily shaking her and crying "Great Gran! Great Gran! Wake up!".

www.ingramcontent.com/pod-product-compliance
Lightning Source LLC
Chambersburg PA
CBHW032021170526
45157CB00002B/806